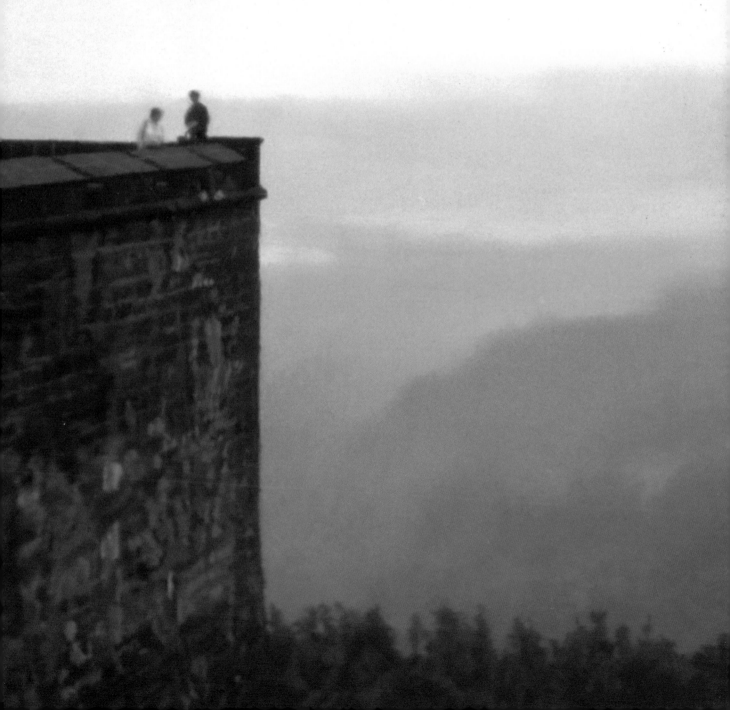

THE INWARD EYE
Transcendence in Contemporary Art

THE INWARD EYE

Transcendence in Contemporary Art

I WANDERED LONELY AS A CLOUD

I wandered lonely as a cloud
That floats on high o'er vales and hills,
When all at once I saw a crowd,
A host, of golden daffodils;
Beside the lake, beneath the trees,
Fluttering and dancing in the breeze.

Continuous as the stars that shine
And twinkle on the milky way,
They stretched in never-ending line
Along the margin of a bay:
Ten thousand saw I at a glance,
Tossing their heads in sprightly dance.

The waves beside them danced; but they
Out-did the sparkling waves in glee:
A poet could not but be gay,
In such a jocund company:
I gazed—and gazed—but little thought
What wealth the show to me had brought:

For oft, when on my couch I lie
In vacant or in pensive mood,
They flash upon that inward eye
Which is the bliss of solitude;
And then my heart with pleasure fills,
And dances with the daffodils.

William Wordsworth
1804

HELEN ALTMAN

JAMES LEE BYARS

VIJA CELMINS

LYNN DAVIS

KATHARINA FRITSCH

ROBERT GOBER

FELIX GONZALEZ-TORRES

RODNEY GRAHAM

ANN HAMILTON

HOWARD HODGKIN

JENNY HOLZER

RONI HORN

ANISH KAPOOR

WOLFGANG LAIB

WALTER DE MARIA

DONALD MOFFETT

ERNESTO NETO

RAYMOND PETTIBON

RACHEL RANTA

CHARLES RAY

GERHARD RICHTER

BRIDGET RILEY

THOMAS RUFF

QIU SHI-HUA

PAT STEIR

NESTOR TOPCHY

JAMES TURRELL

BILL VIOLA

ROBERT WILSON

THE INWARD EYE

Transcendence in Contemporary Art

Essays by

Lynn M. Herbert

Klaus Ottmann

Peter Schjeldahl

Contemporary Arts Museum, Houston

This catalogue has been published to accompany the exhibition
The Inward Eye: Transcendence in Contemporary Art
organized by Lynn M. Herbert, Senior Curator,
Contemporary Arts Museum, December 8, 2001–February 17, 2002.

The Inward Eye: Transcendence in Contemporary Art has been supported
by the Contemporary Arts Museum's Major Exhibition Fund contributors:

Major Exhibition Fund

Major Patron
Fayez Sarofim & Co.

Patrons
Mr. and Mrs. A.L. Ballard
Mr. and Mrs. I.H. Kempner III
Ms. Louisa Stude Sarofim
Mr. and Mrs. Michael Zilkha

Benefactors
Robert J. Card, M.D./Karol Kreymer
George and Mary Josephine Hamman Foundation
Max and Isabell Smith Herzstein
Rob and Louise Jamail
Stephen and Ellen Susman

Donors
Eddie and Chinhui Allen
Andersen
Baker & Botts L.L.P.
Mr. James A. Elkins, Jr.
KPMG LLP
Ransom and Isabel Lummis
Mithoff Family Foundation
Jeff Shankman
Shell Oil Company Foundation
Reggie and Leigh Smith
Mr. and Mrs. Wallace S. Wilson

The exhibition catalogue is supported by The Brown Foundation, Inc.

Library of Congress Catalogue Card Number 2001096568
ISBN 093608071X

Cover: Gerhard Richter, *Fortress at Königstein,* detail, 1987 (page 73)
Frontispiece: Felix Gonzalez-Torres, "Untitled" (Aparición), detail, 1991 (page 43)

William Wordsworth, "I Wandered Lonely as a Cloud" from *The Norton Anthology of English Literature,*
volume 2, edited by M.H. Abrams (New York: W.W. Norton & Co., Inc., 1962), p. 174.

Contemporary Arts Museum
5216 Montrose Blvd.
Houston, Texas, 77006-6598
phone: 713/284-8250
fax: 713/284-8275

Distributed by:
Distributed Art Publishers, Inc. (D.A.P.)
155 Sixth Avenue
New York, New York, 10013
212/627-1999
www.artbook.com

CONTENTS

Carol C. Ballard, Houston

Nancy and Robert Blank

Tanya Bonakdar Gallery, New York

Devin Borden Hiram Butler Gallery, Houston

Mr. and Mrs. Marc Brutten, Delmar, California

Galeria Camargo, Vilaça, São Paulo

James Cohan Gallery, New York

Michael and Eileen Cohen, New York

Paula Cooper Gallery, New York

Dunn and Brown Contemporary, Dallas

Lea and Andy Fastow, Houston

FUNDACIÓN TELEVISA, Mexico City

Robert Gober, New York

Marguerite and Robert Hoffman, Dallas

Edwynn Houk Gallery, New York

Sean Kelly Gallery/Projects, New York

Emily Fisher Landau, New York

Matthew Marks Gallery, New York

McKee Gallery, New York

Galerie Urs Meile, Lucerne

The Menil Collection, Houston

Modern Art Museum of Fort Worth

Moody Gallery, Houston

Museum of Contemporary Art, Los Angeles

Museum of Contemporary Art, San Diego

Private Collection

Private Collection, Houston

Sperone Westwater, New York

Texas Gallery, Houston

Michael Werner, Inc., New York

Zwirner & Wirth, New York

Although this exhibition was conceived well in advance of the horrific events of September 11, it seems especially relevant to the new world that this now infamous date has ushered in. In a recent contribution to a special issue of the Arts section of *The New York Times*, artist Elizabeth Murray wrote:

> A good deal of art is going to seem silly and inconsequential now. . . . [but] I cling to my belief in art as a way for us to try to understand our real situation in life, which is a condition of not knowing. . . . I think that perhaps things will slow down and that it may be good for things to slow down and get quieter so that we can all think and reflect. Maybe there is no understanding but there is opening yourself and trying to continue to grow and hope.[1]

I respectfully suggest that *The Inward Eye: Transcendence in Contemporary Art* is such an opportunity—to reaffirm our humanness, to search for a kind of spiritual respite, to seek hope in a dark and difficult time.

As Senior Curator Lynn Herbert writes in her insightful essay, art is above all an experience, one that can lead us to access both feelings and meanings. To paraphase Robert Motherwell's answer to the proverbial "what is it?" query of the viewer when confronted with an abstract work, "It may not *be* anything, but it sure *means* something." This is in essence the premise of this exhibition: a work of art may not be immediately decipherable, but a significant work of art is one that contains important content, the ineffable sum of its formal elements from which we may discern vital insights that may in fact not be adequately expressed verbally.

The attacks on the World Trade Center and the Pentagon have sadly allowed this exhibition to meet the criteria that the Museum sets for thematic group exhibitions in our Brown Foundation Gallery even more effectively than before. Our long-held policy for shows in this space specifies that we show group exhibitions on topical subjects in contemporary art. I speak for all of us when I say that I wish *The Inward Eye* were perhaps not so acutely relevant.

I am grateful to Lynn Herbert for her original conception of the exhibition and for the intelligence and sensitivity with which she has moved it from idea to reality. Her diligence, scholarship and leadership are welcome to all of us, and we are grateful for her contribution to both our programs and the field as a whole.

On behalf of all the audiences of the Museum, I thank the Board of Trustees for their unwavering loyalty and support; their contributions to our activities cannot be overstated. Along with this remarkable group of trustees stands the staff of the Museum. Each member makes an important contribution to our programs and all give far beyond

the demands of their positions. Senior staff Michael B. Reed, Assistant Director; Karen Skaer Soh, Director of Development; Tim Barkley, Registrar; Paula Newton, Director of Education; and Ms. Herbert provide the institution with effective guidance and the example of serious commitment.

Exhibitions in the Brown Foundation Gallery are made possible by the continuing, enthusiastic, resolute, and vital support of the individuals, foundations, and corporations who form the Major Exhibition Fund. The members of this critical support group listed on page 6, truly form the backbone of the Contemporary Arts Museum. All those we serve are grateful for their insight, their staunch dedication to our mission and programs, and their prescience. The Brown Foundation, Inc., has been a longtime supporter of this institution and has distinguished our scholarship with a three-year grant supporting the Museum's exhibition publications, including this one. The Brown's recognition of the importance of the catalogues that accompany Museum–originated exhibitions is critical to our reaching a wider public, allowing our projects a life beyond the time they are actually on view.

As a non-collecting institution, we regard the lenders to our exhibitions as more critical to our success than is the case with most museums, and we are grateful to the individuals and institutions listed on page 8 who have participated in this project with the loan of works of art. Without their generosity, *The Inward Eye* would have remained only an interesting thought. As Ms. Herbert so aptly cites in her essay, the verbal would have trumped the visual, resulting in "a continued denial of the value of material in art."

In addition to Ms. Herbert's contribution, we are privileged to present wonderful essays by Klaus Ottmann and Peter Schjeldahl. Both make major contributions to the publication, adding significantly to our perception of the exhibition's premise and to our experience of these works of art.

Ms. Herbert would like to thank the following for their advice, counsel, support, and enthusiasm during the formative stages of the project: the artists Uta Barth, Nancy Burson, and David McGee; Kimberly Davenport, Director, Rice University Art Gallery, Houston; Hugh Davies, Director, Museum of Contemporary Art, San Diego; Robert Rosenblum, Professor of Art, Columbia University, and Adjunct Curator, Solomon R. Guggenheim Museum, New York; and Don Quaintance, principal, Public Address Design. Edward Hirsch, John and Rebecca Moores Professor in the Creative Writing Program and the Department of English, University of Houston; and Jim Cohan, Klaus Ottmann, and Betty Palmquist also provided helpful insights and encouragement.

Important assistance has been provided to Ms. Herbert by Michael Auping and Marci Driggers, Modern Art Museum of Fort Worth; Douglas Baxter, Pace/Wildenstein, New York; Tanya Bonakdar and Ethan Sklar, Tanya Bonakdar Gallery, New York; Michael Bond, assistant to James Turrell, Flagstaff, Arizona; Hiram Butler and Devin Borden, Devon Borden Hiram Butler Gallery, Houston; Claudia Carson, Robert Gober's studio, New York; Julie Chiofolo, Regen Projects, Los Angeles; Jessica Chiu, Qui Shi-hua's daughter, San Francisco; Angela Choon and Hannah Schouwink, David Zwirner, New York; Jim Cohan and Julia Sprinkel, James Cohan Gallery, New York; Susan Davidson and

Elizabeth Lunning, The Menil Collection, Houston; Hugh Davies, Tamara Bloomberg, and Becky Klein, Museum of Contemporary Art, San Diego; Talley Dunn, Dunn and Brown Contemporary, Dallas; Stephen Friedman, Patricia Kohl, and Gaia Alessi, Stephen Friedman Gallery, London; Rick Gardner, Houston; Alanna Gedgaudas, Jenny Holzer studio, Hoosick Falls, New York; Marian Goodman, Leslie Nolen, and Jeannie Freilich-Sondik, Marian Goodman Gallery, New York; Kathleen Hill, independent art consultant; Fredericka Hunter, Ian Glennie, and Chas Bowie, Texas Gallery, Houston; Sean Kelly, Jarka Dearstyne, and Debra Vilen, Sean Kelly Gallery/Projects, New York; Barbara Kirschner and Geoffrey Wexler, RW Work, Ltd./Byrd Hoffman Water Mill Foundation, New York; David Leiber and Walter Biggs, Sperone Westwater, New York; Renee Conforte McKee, McKee Gallery, New York; Robert McKeever, Gagosian Gallery, New York; Urs Meile, Galerie Urs Meile, Lucerne, Switzerland; Diana Mogollon De Olmedo, Fundacion Televisa, Mexico City; Tanya Murray, Edwynn Houck Gallery, New York; Peter Pakesch and Rafaela Pichler, Kunsthalle Basel, Switzerland; Jeffrey Peabody, Lora Reynolds, and Adrian Rosenfeld, Matthew Marks Gallery, New York; Andrea Rosen and Michelle Reyes, Andrea Rosen Gallery, New York; Paul Schimmel and Melissa Altman, The Museum of Contemporary Art, Los Angeles; Ivan Vera, Cheim & Read, New York; Lydia Vivante, Fisher Landau Center, New York; Tracy Williams and Shamus Clisset, Zwirner & Wirth, New York; Jason Duval and Gordon VeneKlasen, Michael Werner, New York; and Paulette Young and Polly Botti, Whitcom Partners, New York.

Ms. Herbert wishes to thank the three interns who helped with this project: Karmin Guzder from New York University, who provided assistance with research for the catalogue and exhibition, and Billy Baron and Peggy Ghozali from the University of Houston, who provided important support with various aspects of the project, particularly in the compilation of the artists' biographies. Ms. Herbert would also like to acknowledge with gratitude the staff of the Contemporary Arts Museum, each member of which has made significant and valuable contributions to the project. In particular, she wishes to thank Paula Newton, Director of Education, and Claire Chauvin, Webmaster, who have provided unfailing and enthusiastic input throughout the planning and presentation of the exhibition. A special thanks is ever due to Don Quaintance and Elizabeth Frizzell of Public Address Design, who might as well be staff members given their constant contributions to our programs. They have designed and produced this publication with attention to their own "inward eye."

Foremost, we are grateful to the artists, whose profound work will continue to provide us with the kind of memorable encounters this exhibition celebrates.

—Marti Mayo
Director

1. Elizabeth Murray, "Clinging to Belief in Art," in "The Aftermath, Arts," *The New York Times*, September 22, 2001, Section AR, p. 29.

Lynn M. Herbert

When William Wordsworth (1770–1850) wrote "I Wandered Lonely As A Cloud" (page 3), he was writing about a memorable moment whose import didn't become clear to him until later. Wordsworth didn't sit down to write the poem until fully two years had passed after his encounter with the "golden daffodils." At the time, as he writes: "I gazed—and gazed—but little thought/What wealth the show to me had brought." But he came eventually to understand the nature of that wealth: "For oft, when on my couch I lie/In vacant or in pensive mood,/They flash upon that inward eye/Which is the bliss of solitude;/And then my heart with pleasure fills,/And dances with the daffodils."

Wordsworth's poem is about the inner self—the sense of losing and finding oneself at the same time—and about the lasting impact of one's own immediate experience. Thinking back to that walk through nature's bounty, gazing upon it with his "inward eye," Wordsworth discovered that he could inhabit the joy of that initial moment all over again.

This exhibition, *The Inward Eye: Transcendence in Contemporary Art*, takes its title and cue from Wordsworth's poem. It, too, is about a considered kind of looking and subsequent seeing. It is about the joy and pleasure such seeing can bring—in this case, from within the realm of contemporary art. It is about strolling through a museum, just as Wordsworth strolled through the countryside, and having a profound encounter with a work of art along the way. It is about discovering highly personal connections with these objects. In that sense, it is an exhibition as much about the viewer as it is about the art.

Such reverie does not come easily these days, nor does the formulation of such an exhibition. Both involve breaking a number of unspoken rules. The twenty-nine works presented in this exhibition were selected not by traditional reasoned methods, but rather by intuition. They are all works that have elicited "gasps of aesthetic response"[1] from the curator—works that have taken my breath away, brought my hand to my heart, summoned forth an aaahhh from deep within. Many would consider it an indulgence to rely solely on one's intuition, but for this exhibition, that seemed the most practical strategy: in looking for art that has the potential to profoundly move a viewer, one logically picks works that already have proven their mettle with oneself. One consequence is that this exhibition, selected solely on the basis of each work's visceral impact on one person, has no beginning, middle, or end. It is left to viewers to go where the eye will take them. To give each work its full due, the playing field has been leveled as well: each work is silent, relatively small, and presented in relative isolation. The museum, which traditionally provides support material in a variety of media, from extended labels to art-phone recordings, has also done its best to "get out of the way."[2]

Whatever happened to the pleasure of looking at a work of art and the subsequent "seeing" that can ensue? Or the joy of discovering for yourself what a work of art might mean to you and to you alone? Children haven't lost that ability, but we as adults have apparently abandoned that experiential and personal way of looking at art. Today our interaction with the visual arts seems to be driven primarily by our culture's obsession with "meaning": with explanatory texts, rigorously prepared guides, and definitive answers. A significant faction of the art world appears to be doing its best to drain all the nuance, poetry, and mystery out of art. Critical theory in recent decades has moved progressively further away from the objects themselves to the point that they are rarely if ever even discussed. As one theorist has noted; "The contemporary fascination with unreadable theory, and the often incomprehensible art it spawns, would seem to indicate a continued denial of the value of material in art."[3] In the battle between the verbal and the visual, it would seem that the verbal has won.

Contemporary art has suffered particularly, taking direct hits on many fronts. Yes, incomprehensible theory has weakened the public's uncertain relationship to contemporary art, but politics—always a factor with the art of one's own time—has contributed as well to contemporary art's perception problem. Throw into the equation our increasingly fast-paced life, and you might find yourself wondering why anyone would take the time to look at contemporary art anymore. But there *are* still times when we find ourselves receptive to experiencing the arts. They tend to be at times of extremity, "when we experience a great deal of ugliness or beauty, a great deal of fear or love, a great deal of loneliness or intimacy."[4] And just as in former times one might have gone into a church or ventured forth into nature for solace or to feel a sense of belonging, today museums have emerged in society as "sanctuaries of respite and contemplation."[5]

In an essay on the subject of childhood and adolescence in contemporary art, curator Kirk Varnedoe has noted:

> In intellectual life, it has been one of the conceits of our age to pride ourselves on our loss of illusions, and to count ourselves superior by virtue of a more thoroughgoing cynicism. Much of the writing about art in recent decades has, in this spirit, trumpeted the force of new art and new thought as that of debunking and discarding the ideals and mythologies—of autonomy, of teleology, of universality, of purity—that permeate the rhetoric of earlier modern art.[6]

Though those ideals and mythologies haven't altogether vanished, in recent decades our attentions have been focussed elsewhere. And yet there is a growing disenchantment with this approach: an increasing number are tired of debunking and tired of cynicism, longing instead for an art they can know without naming—art they can revel in and linger with.

Beauty, of all things, would appear to have been the icebreaker. Approached begrudgingly at first and with great suspicion, beauty is now readily accepted as a serious topic for discussion.[7] Perhaps we are finally ready to listen to painter Agnes Martin, now in her nineties, who once said : "Our emotional life is really dominant over our intellectual life, but we do not realize it."[8]

Transcendence. Now there's a word that makes people nervous and one that the debunkers excluded long ago from critical discourse. For the purposes of this exhibition, I am stripping "transcendence" of all its baggage and restoring it to its dictionary definition. The verb "to transcend" means to rise above or to go beyond the limits of. The adjective "transcendent" means extending beyond usual limits—surpassing, exceeding. The noun "transcendence," then, is defined as the quality or state of being transcendent, of having gone beyond the limits of ordinary experience.

This exhibition explores how someone can look at a work of contemporary art and be transported, going beyond the given limits to another place entirely, in effect accessing one's spiritual side.[9] This concept is not new in art history. The German painter Caspar David Friedrich (1774–1840), a pioneer in the Romantic movement, showed us with his meditative landscapes how "all earthly paths, whether humble or exalted, lead to the unknown."[10] Poets, philosophers, writers, and musicians in his day sought ways to access the spirit from the material world, an approach previously the exclusive purview of religion. The Russian painter Wassily Kandinsky (1866–1944) later took up a similar torch. He, too, pursued a form of spiritual expression, but he found it in abstract form much like the Abstract Expressionists who were to follow him in the 1950s and early 1960s, including Barnett Newman (1905–1970), Mark Rothko (1903–1970), and Ad Reinhardt (1913–1967). While the artists included in this exhibition are not part of any formal neo-romantic or spiritual movement, their works would suggest that the impulses that inspired the likes of Friedrich, Kandinsky, and the Abstract Expressionists have found a similar voice in the art of today.

How do we describe this transcendence, this spiritual release? Historian Roger Lipsey has one explanation: "It needn't even be called 'the spiritual,' but words of some kind will be found to describe an intelligence, a vitality, a sense of deliverance from pettiness and arrival at dignity that always seems a gift. It includes a perception of grandeur in the world at large, which cannot help but strike one as sacred, quite beyond oneself and yet there to be witnessed and even shared in."[11] The works in this exhibition offer this kind of experience in a variety of ways. Through them we can discover what poet Robert Frost (1874–1983) called "the pleasure of ulteriority."[12] We can know what it feels like to be swept away. We can explore the realm of reverie and pluck from "the fruit of the subconscious."[13] We can actively observe the flow of consciousness, feeling the "outer standstill and inner movement" of German poet Rainer Maria Rilke (1875–1926).[14] We can sense joy, experience grace, and commune with the sublime. Like "matches struck unexpectedly in the dark,"[15] each work opens up a shaft of knowing, a truth that is at once personal and universal. We come to experience "the self surrendered to the sublimity of the non-self."[16] We "hear" and listen to silence. We revel in stillness.

Claims to achieve this "irreducible, non-discursive experience"[17] might be dismissed by the knee-jerk debunkers in our midst, but now even the realm of science (home to a large contingent of debunkers itself), acknowledges and can even measure the intensity of such a meditative experience. Scans have pinpointed which areas of our brain go into high gear and which become dormant when we have such an experience, and studies show how we can "instruct" our brains to allow for this different awareness.[18] Those of us who work in places like museums, where people continually come in contact with works of art, know firsthand how art can facilitate a kind of transcendence. We're the ones who get the call from a terminal patient who has been so moved by a Maya Lin sculpture that she is desperate for a reproduction of it that she can share with her doctor. And we witness phenomena such as how couples standing in front of a joyous, larger-than-life assemblage by Trenton Doyle Hancock, invariably kiss one another before moving on to the next work in the exhibition. Or it's the smile, damp eyes, and speechlessness of a visitor who approaches you and squeezes your arm after a profound encounter with a suite of Matthew Ritchie drawings. We see the large and boisterous crowd file through a dark passage to enter a James Turrell installation only to fall suddenly silent in the presence of his light. And hear the Jungian analyst leading the group explain, "That's what we do in the presence of the numinous." This exhibition is about that intensity. About humanity and how it fits into the equation. This is not the view from back at command central, or from an ivory tower, but from down where objects and people meet face to face.

How do these works of art speak to us in such a profound way? Although personal responses will be up to each individual, many of the works have elements in common— points of departure or portals, if you will—including nature, time, perception, allegory, the sensorium, essence, color, and memory.

Early in the nineteenth century, the Romantics championed nature for its extraordinary communicative power: "The Romantics believed that the simplest forms of Nature could speak directly to us, could express sentiments and ideas without the intervention of culture; they dreamed of creating through landscape an art both personal and objective, an immediate, nonconventional, universally intelligible expression, a language that would not be discursive but evocative."[19] Pat Steir's *Waterfall des Rêves* [*Waterfall of Dreams*] (1990, page 79) is just such a universal work, an abstract painting that is, on the one hand, a composition in black and white and on the other, a curtain of water with all of nature's cleansing fluidity and engaging irregularity. According to psychologist James Hillman, "Beauty cannot enter art unless the mind in the work is anchored beyond itself so that in some way the finished work reflects the sacred and the doing of the work, ritual."[20] Steir's long-term commitment to the study of falling water in her abstract paintings suggests just such a meditative ritual. Like Steir's waterfall paintings, Qiu Shi-hua's *Untitled* (1996, pages 66–67) at first glance appears to be one thing— a monochromatic painting—but those who persevere and really look will discern in its misty depths something of the barren landscape of northwest China. Describing his process, the artist has said: "Imagine the mind turned down to a dormant state, degree zero, then the world would look so clear, so vivid."[21]

Rodney Graham and Lynn Davis draw on nature using photography. Oak trees were once worshiped by the Celtic cult of Druids, and we find ourselves respectfully pausing as well at Graham's *Oak Tree, Banford, Oxfordshire, England, Fall 1990* (1990, page 45). In this somewhat conceptual work, Graham presents his stalwart tree upside down, a potentially jarring gesture that instead reveals the tree's beautiful form and the often hidden symmetry in nature: in our minds we create a kind of instant duality in which the branches and the root system simultaneously mirror one another. Its sepia tone and upside-down format[22] lend a nineteenth-century air to Graham's work, a historicizing that can also be found in Davis' *Iceberg #5, Disko Bay, Greenland* (1988, page 37). Davis brings us the thrill of exploring the unknown by taking us to a remote corner of the globe to capture the eerie majesty of nature. As the icy form slowly emerges out of her atmospheric light, we notice the ripples in the water and their scale in relationship to this enigmatic shape, awestruck by the vastness of this sculptural mountain of ice.

Vija Celmins' meticulously crafted *Ocean Surfaces* (2000, page 35) brings us back to the intricacies of the surface of the ocean itself. As diminutive as its subject is vast, Celmins' print concentrates the power of her subject into an object one can hold in one's hand, magnifying both the meditative, rhythmic undulation of the water and the patterned irregularity of its movement. With each engraved line, Celmins makes manifest the words of writer Victor Hugo (1802–1885) who wrote: "The sea observed is a reverie."[23]

Wordsworth's words, "For oft, when on my couch I lie/In vacant or in pensive mood," come to mind when we encounter Rachel Ranta's *Cloud* (1994–2001, pages 68–69). Through a window, we watch as a single white cloud slowly makes its way across a pale blue sky. The words inscribed below Ranta's windows—"time to go, hard to hide, year to date, have to have, down to earth, out to lunch, fade to black"—suggest a random

word game, a stream of consciousness exercise registering thoughts that go through one's mind in the time that it takes a cloud to pass by. Celmins' and Ranta's suspension of time is reminiscent of that in Friedrich's landscapes. As art historian Robert Rosenblum has noted, "The continuous ticking of measurable time that clocks our ordinary lives seems to have stopped as Friedrich transports us to an otherworldly experience of rapt meditation in which the next movement—the setting of the sun, the rising of the moon, the passing of a cloud—may take us beyond the threshold of the natural world."[24]

Bill Viola's *The Locked Garden* (2000, page 85), similarly, takes us beyond that threshold into a different kind of time, a time so confounding that we feel as if we've entered a different dimension. He presents us with a video diptych showing the faces of a man and a woman, small domestic portraits like those found on the dresser in any household, a subject we all know something about, images that we feel we can read and understand. But inside Viola's work we discover a kind of "technosublime."[25] Even as the man's and the woman's expressions simultaneously shift from joy to sorrow to anger and fear, Viola has slowed them down, shooting many more frames per second than we are accustomed to seeing. As such, we find ourselves virtually inside all those emotions that we thought we knew so well, suddenly unable to read them.

Time in Bridget Riley's *Orphean Elegy 5* (1979, page 75) is revealed as rhythm. One doesn't have to know that Orpheus was the musician in Greek myth whose lyre was said to move rocks and trees to feel the music in Riley's undulating lines. Her painting has all the curves, grace, elegance, and tropical sensuality of Antonio Carlos Jobim's *Girl from Ipanema*: "When she walks, she's like a samba/That swings so cool and sways so gently/that when she passes, each one she passes goes 'aaahhh.'" Swaying is a natural response in front of such a painting. As your eyes move up and down Riley's colorful curves, you find yourself getting lost in their optical play: you follow a line until it disappears, follow another line until it disappears, and on and on.

We also experience what it is to see ourselves seeing in the works by James Turrell and Charles Ray. Turrell's *Zarkov* (1998, page 83) at first appears to be a luminous monochromatic painting until we notice that its color is continually changing, albeit in a very subtle manner. As we get closer, we discover that the painting in fact has no substance at all, but rather is a hole in the wall. Turrell invites us to become what he has called "intronauts," looking within to fathom his works made of light.[26] In this case, the soothing, seductive light comes, ironically enough, from the riot of images emitted by a television set. *Zarkov* adds a contemporary twist to the quip that Rothko's paintings look like "Buddhist television sets."[27]

Ray's equally reductivist *Rotating Circle* (1988, page 71) looks at first glance as if the artist simply drew a circle on the wall, a Minimalist gesture indeed. But if you move in for a closer look, you are rewarded with the discovery that it isn't a drawn circle at all, but a disk, seemingly cut right out of the wall, that is spinning around. In 1931, Kandinsky wrote: "Today a point sometimes says more in a painting than a human figure. . . . The painter needs discreet, silent, almost insignificant objects. . . . How silent is an apple beside Laocöon. A circle is even more silent."[28]

The works by Walter de Maria, Roni Horn, and James Lee Byars also employ simple geometric shapes in works that draw particular strength from their materiality. De Maria shows us that something as seemingly innocuous as a rectangular bar of stainless steel, too, can speak volumes. The small size of his *High Energy Bar* (1966, page 59) belies the uncanny magnetic and elemental force that the work exudes. De Maria's bar mysteriously embodies solidity, gravitas, and essence. Could we but feel its weight resting in our hands, we would begin to feel its energy course through our veins.

Horn's *Gold Field* (1980–82, page 53) takes a step even closer to the elemental, using not a man-made metal, but a material mined directly from the earth's crust—gold. Her resplendent field of gold, simply gold, brings a heavenly presence right to our very feet. Fellow artist Felix Gonzalez-Torres reacted in 1990 to this work:

> How can I deal with the *Gold Field*, I don't quite know. But the *Gold Field* was there. Ross and I entered the Museum of Contemporary Art, and without knowing the work of Roni Horn, we were blown away by the heroic, gentle, and horizontal presence of this gift. There it was, in a white room, all by itself—it didn't need company, it didn't need anything. Sitting on the floor ever so lightly. A new landscape, a possible horizon, a place of rest and absolute beauty. Waiting for the right viewer willing and needing to be moved to a place of the imagination. This piece is nothing more than a thin layer of gold. It is everything a good poem by Wallace Stevens is: precise, with no baggage, nothing extra. A poem that feels secure and dares to unravel itself, to become naked, to be enjoyed in a tactile manner, but beyond that, in an intellectual way too. Ross and I were lifted. That gesture was all we needed to rest, to think about the possibility of change.[29]

There is a similar air of fragility and purity in Byars' *Slit Moon* (1994, page 33). Heaven and earth come together again in this thin moon carved out of Thassos marble, a favorite of Byars' for its unrivaled pure white. Just bigger than the span of one's hand, as small as the moon so often seems high in the night sky, Byars' work pays evocative homage to the essential force that moves our oceans and illuminates our nights.

While we might want to gently trace our fingers along the smooth curve of Byars' marble moon, Ernesto Neto's *Glop* (1998, page 63) cries out for a full hug. As warm and soft as Byars' moon is cool and hard, Neto's *Glop* grabs us, whether with its playful onomatopoetic title or with its alluring abstract form laden with human sensuality—its malleable body is barely contained by a skin of pantyhose and its all-too-human orifice is filled with ground red pepper. With *Glop*, the visceral shuts the cerebral down, shakes our senses awake, and rouses all manner of primal urges.

While *Glop* comes at our emotions through our senses of touch and smell, triggering a heightened awareness of our own bodies, works by Donald Moffett and Howard Hodgkin reveal how emotive color itself can be. Moffett's *#10* (Lot 081200) (2001, page 61) is the tenth and largest of *The Incremental Commandments*, a series of black paintings (each a different black) that reference the Ten Commandments and increase in size incrementally from #1 to #10. Often dismissed as a non-color, black here is revealed as charismatic and powerful. The surface of the painting is alive with thousands of tiny, pointed, tentacle-like extrusions of paint; these mysterious forms give us the feeling that

we're looking at some kind of dark living underbelly. Entranced by this veritable sea of curious nodes, our eyes dance across the reflective surface, only to plunge unannounced into dark and endlessly deep holes where the black seems to reach out and swallow up all available light. *#10* allows us to experience what it is like to have to pull oneself out of a painting.

Hodgkin's *Dinner at Palazzo Albrizzi* (1984–88, page 49) is as colorful as Moffett's *#10* is monochromatic. In this intense expressionist painting, Hodgkin presents us with a thrilling blast of unabashed, over-the-top color. Through marks, gesture, and his signature bold use of color, the artist invites us to share in his reverie of a remembered dinner. Bathed in this magnificent light, one can only wonder how it is that our culture has become so chromophobic.[30]

The written word, too, can be a strongly emotive tool in art, as seen in the works by Jenny Holzer and Raymond Pettibon. In very different ways, both artists are like roving reporters, their eyes always on contemporary culture. Holzer gets back to us with carefully crafted, concise, and declarative statements. In this 1998 footstool from her *Survival Series* (page 51), a work that she created for a Doctors of the World benefit, Holzer has literally etched her title in stone: "In a dream you saw a way to survive and you were full of joy." Holzer's seriousness of purpose is underscored by the formal typeface, the all-capital letters, and the solemn marble slab into which they are etched—and we are heartened by the implied authority she has given to these words of hope.

In contrast, Pettibon's words adopt a more informal, almost spontaneous stance. Known for the uncannily fluid dexterity with which he has produced a prolific series of cartoon-like illustrations, Pettibon plucks bits and pieces from popular culture and serves them up to us for reappraisal. In *The sky was very far . . .* (1994, page 65), Pettibon presents us with his trademark small sheet of paper, here simply bearing a large blue circle with a handwritten message inside it: "The sky was very far/Yet now and then/It seemed as if my weakest words/Must sound in its farthest distances/Like a clap of thunder." Measured though the words are, Pettibon's presentation lends them the fleeting sensation of a momentary flash of thought, one soulful cry from the dark.

The sky is also invoked in Robert Gober's *Prison Window* (1992, page 41), one of several works in the exhibition that lure us with allegory. Gober's barred window appears in the room's architecture as if from out of nowhere, looming overhead and out of reach, in effect imprisoning us below. It is just us, the bars, and the blue sky beyond. While imprisoned, poet Paul Verlaine (1844–1896) wrote: "The sky is up above the roof/So blue, so calm."[31] Gober's work summons that same sense of disparity, making us aware, even as we yearn toward the promise of his serene sky, of all the barriers that lie between.

Like Gober's window, Anish Kapoor and Wolfgang Laib's works appear mysteriously embedded in the walls, looking as if they had always been there. But Kapoor's *The Healing of St. Thomas* (1989, page 55), rather than being a portal, seems more akin to a wound in the very fabric of the building. His title alludes to the doubting Apostle who refused to believe in Christ's Resurrection until he could be convinced by sight and

touch. As reported in John 25:27, Christ appeared after the Resurrection and invited Thomas to "reach hither thy hand, and thrust it into my side, and be not faithless but believing." Even as it anthropomorphizes the room's architecture, Kapoor's abstract, yet ever-so-human slit in the wall, filled with a rich red pigment, reminds us of our own vulnerability to doubt.

Laib's Untitled (Wachshaus) (1993, page 57) makes itself known in an unassuming and quiet way. Some may even smell it before they notice it floating overhead. Made of aromatic beeswax, the material secreted by bees for their honeycombs, Laib's house hovers high on beams, raised above the day-to-day goings-on. With no windows, doors or other embellishments, it is an elemental and universal dwelling. Its extended length suggests an Iroquois longhouse, a communal place for gathering, elevated into a serene eyrie.

Equally allegorical and also making allusions to bees is Ann Hamilton's *untitled (privation and excesses)* (1989, page 47). Hamilton gives herself four elements with which to work: a metal chair, a cloth, a felt hat, and honey. The simplicity of this ground-level still life is perhaps what strikes us first. As we get closer, something much more surreal emerges: a hat filled with honey. The arrangement suggests a function, work to be done, and Hamilton indeed employed these elements as part of a larger installation of the same title: seated in the chair, with the cloth draped over her lap, she had repeatedly dipped and wrung her hands in the honey. Today the elements stand alone, mysterious and suggestive.

While the objects in Hamilton's still life are somewhat enigmatic, those in the works by Katharina Fritsch and Helen Altman are clearly iconographic, symbols that exist in our collective memory. Fritsch draws from such sources as mythology, Christianity, and folk tales, finding in them a wealth of icons that already have a home in our minds. Sometimes Fritsch's works venture to the dark side, and *Totenkopf [Skull]* (1997–98, page 39) is a meticulously rendered, painted porcelain replica of a human skull, an object with which we are all well acquainted. A classic symbol of vanitas, of the transitory nature of our life on earth, the skull in Fritsch's work points not to an individual's death, but rather to our collective mortality.

Fritsch's comment, "I think everything comes from childhood,"[32] speaks to Altman's *Snowhead* (1992, page 30–31), which taps into everyone's childhood memories, whether real or culturally imprinted. Through the window of a freezer, we peer in and see a snowman with coal eyes, a jaunty carrot nose, and a wide grin. He's as folksy as Fritsch's rendition is precise, conjuring up the popularized wonders of childhood. Preserved only for the moment, destined ultimately to melt, Altman's snowman reminds us of how we hold on to and often treasure such fleeting memories.

Romantic in a different way are Gerhard Richter's *Fortress at Königstein* (1987, page 73) and Nestor Topchy's *Fête Champêtre* (1996, page 81). With its two lone figures standing on an antiquated castle rampart, looking out over a vast landscape, Richter's painting can be seen as an homage to his countryman, Friedrich. Rosenblum's discussion of a Friedrich painting of figures before a landscape, applies equally here: ". . . we have been elevated to an exalted destiny that can no longer be entered by physical means. The

prevalence in Friedrich's works of figures who stand mesmerized, singly or in pairs, before these mirages, their backs to the spectator, reinforces this experience of having arrived at the last outpost of the terrestrial world, beyond which there are only spiritual means of transportation."[33] As Friedrich did before him, Richter manages to capture what Rosenblum describes as "the sense of total human isolation before the numbing mysteries of transitory life on earth."[34]

Topchy similarly draws on the history of painting, incorporating a seventeenth-century Dutch painting into his collage. His title, *Fête Champêtre*, refers to a genre of painting in which figures contemplatively enjoy pastoral surroundings. Into this landscape, Topchy has injected a swirling force that seems to come from Nature herself. Humble hole punches metamorphose into a cosmic force, but rather than disturb the peace of the landscape's inhabitants, Topchy's whirlwind seems to reinforce their reason for being there.

Thomas Ruff's *Stern 11h 16m/-40* (1992, page 77) presents us with another cosmic vision: a fragment of star-filled sky. Marrying art and science, Ruff printed the photograph from a negative he purchased from an observatory's archive. And yet this is as much Ruff's night sky as *Starry Night* (1889) was Vincent Van Gogh's. Its shape and scale turn what was once an astronomical notation into a doorway, and places us at its threshold with the mysteries of the universe within our reach. It is a small matter to step right through to bask in Ruff's "poetisphere."[35]

Robert Wilson's *Blue Geese* (1994, page 87) too, lifts our focus upward, up to the sight of three sky-blue geese flying overhead. Wilson's flock of enchanted blue geese was inspired by a Native American myth, "The Waterjug Boy"—and here, three of his flock soar in V formation. Their natural symmetry, dignity, and grace make us want to rise up on their wings and experience their free flight. In classical literature and philosophy, the soul is associated with air, and in Romantic poetry, birds came to represent the soul. Just as Wilson's geese helped the Waterjug Boy discover his identity, they can also help acquaint us with our own deeper self.

Felix Gonzalez-Torres strove to reach his audience in more immediately tangible ways. In "Untitled" (Aparición) (1991, page 43), we find a number of pristine stacked sheets sitting without fanfare on the floor. Using his trademark "stacks," Gonzalez-Torres sought to make a new kind of public art, one in which the public could actually participate by taking a sheet home with them. "Untitled" (Aparición) is another such graceful gesture in which Gonzalez-Torres brings the empyrean, a bit of heaven, within our reach.

In the end, what "Untitled" (Aparición) and the other works in this exhibition offer is a way to engage life's great mysteries and intangibles. A kind of contemporary cabinet of wonders, this exhibition is a small sampling of how contemporary artists in recent decades have explored this realm. Different though the works may be, they underscore how our deepest questions unify us, creating a kind of universal we, triggering what Marcel Proust (1871–1922) has called our "involuntary memory." Through them we can experience knowing without naming and begin to understand what philosopher

George Santayana (1863–1952) meant when he wrote: "To feel beauty is a better thing than to understand how we come to feel it."[36]

Early in the twentieth century, artist Piet Mondrian (1872–1944) observed that we have "a nostalgia for the universal" and as we enter into the twenty-first century, one could argue that we are feeling a similar kind of nostalgia.[37] But to find the universal in art requires active participation. It requires breaking away from passive acceptance of institutional or academic doctrine, and becoming personally involved with a work of art. Early in the nineteenth century, poet Ralph Waldo Emerson (1803–1882) called upon individuals to join in just such a journey of discovery: "The foregoing generations beheld God and nature face to face; we through their eyes. Why should not we also enjoy an original relation to the universe? Why should not we have a poetry and a philosophy of insight and not of tradition, and a religion by revelation to us, and not the history of theirs?"[38]

The works in this exhibition invite viewers to further discover their own "original relation to the universe," to know the self both lost and found, to feel "the astonishment of being,"[39] "the raw actuality of existence," and "the immediacy of life."[40] Through them we can share in Wordsworth's reverie: "And then my heart with pleasure fills/And dances with the daffodils." And we can discover that literary scholar Harold Bloom could just as well have been writing about the works presented in this exhibition when he wrote about the poetry of Wordsworth's era: "The great poems do not champion any cause or urge any vision but one: to know ourselves, sincerely, in our own origins and in what we still are."[41]

1. James Hillman, "The Practice of Beauty," in *Uncontrollable Beauty: Toward a New Aesthetics*, edited by Bill Beckley with David Shapiro (New York: Allworth Press, 1998), p. 273.

2. The museum has still provided support materials, but they have been designed to offer insight rather than interpretation.

3. Debra Koppman, "Thou Art: The Continuity of Religious Ideology in Modern and Postmodern Theory and Practice," in *Reclaiming the Spiritual in Art: Contemporary Cross-Cultural Perspectives* (New York: State University of New York Press, 1999), p. 147.

4. Roger Lipsey, *An Art of Our Own: The Spiritual in Twentieth Century Art* (Boston: Shambhala Publications, Inc., 1988), p. 8.

5. From an advertisement in *The New York Times*, September 15, 2001, in which eleven of New York's most prominent art museums invited people to come to their institutions free of charge in the aftermath of the terrorist attack on the World Trade Center on September 11, 2001.

6. Kirk Varnedoe, "Wednesday's Child," in *Modern Contemporary: Art at MoMA Since 1980* (New York: Museum of Modern Art, 2000), p. 539.

7. See Dave Hickey's *The Invisible Dragon: Four Essays on Beauty* (New York: Distributed Art Publishers, 1994); and Neal Benezra, Olga Viso, and Arthur C. Danto, *Regarding Beauty: A View of the Late Twentieth Century* (Washington, D.C.: Hirshhorn Museum and Sculpture Garden, Smithsonian Institution, 1999).

8. Agnes Martin, "Beauty Is the Mystery of Life," in *Uncontrollable Beauty*, p. 400.

9. "Spiritual" is another word that makes people nervous. As Roger Lipsey has written, "Spiritual is an old-fashioned word, recalling eras in which people were more sure of themselves and of the order of things divine and human." Lipsey, *An Art of Our Own*, p. 6.

10. Robert Rosenblum, "Friedrichs from Russia: An Introduction," in *The Romantic Vision of Caspar David Friedrich: Paintings from the U.S.S.R.*, edited by Sabine Rewald (New York: Harry N. Abrams, Inc. with The Metropolitan Museum of Art, New York, and The Art Institute of Chicago, 1990), p. 6.

11. Lipsey, *An Art of Our Own*, p. 9.

12. Edward Hirsch, *How to Read a Poem and Fall in Love with Poetry* (New York: Harcourt Brace and Company, 1999), p. 13.

13. Gaston Bachelard, *The Poetics of Reverie: Childhood, Language and the Cosmos*, translated by Daniel Russell (Boston: Beacon Press, 1971), p. 1.

14. Hirsch, *How to Read a Poem*, p. 253.

15. Virginia Wolff, quoted in Hirsch, *How to Read a Poem*, p. 227.

16. Homi K. Bhaba, "Aura and Agora: On Negotiating Rapture and Speaking Between," in *Negotiating Rapture: The Power of Art to Transform Lives* (Chicago: Museum of Contemporary Art, 1996), p. 10.

17. Donald Kuspit, "Concerning the Spiritual in Contemporary Art," in *The Spiritual in Art: Abstract Painting 1890–1985* (New York: Abbeville Press Publishers and Los Angeles County Museum of Art, 1986), p. 319.

18. For further information on research in the new field of "neurotheology," the study of the neurobiology of religion and spirituality, see Sharon Begley, "Religion and the Brain," *Newsweek*, May 7, 2001, pp. 50–57.

19. Charles Rosen and Henri Zerner, *Romanticism and Realism: The Mythology of Nineteenth Century Art* (New York: Viking Press, 1984), p. 59.

20. Hillman, "The Practice of Beauty," p. 273.

21. Qiu Shi-hua, quoted in Max Wechsler, "Painting on the furthest edges/slowness of painting/in extremis," in *Qiu Shi-hua* (Basel, Switzerland: Kunsthalle Basel, 1999), n.p.

22. When using the large-format cameras of the nineteenth century, photographers "previewed" the image that was to be photographed on a ground glass. That image was projected onto the ground glass upside down.

23. Victor Hugo, quoted in Bachelard, *The Poetics of Reverie*, p. 12.

24. Rosenblum, "Friedrichs from Russia," p. 9.

25. For more on the "technosublime," see Jeremy Gilbert-Rolfe, "Beauty and the Contemporary Sublime," in *Uncontrollable Beauty*, pp. 39–51.

26. From Craig Adcock, *James Turrell: The Art of Light and Space* (Berkeley: University of California Press, 1990), p. 76.

27. Quip cited by Robert Rosenblum in "Isn't It Romantic?" *Artforum* (May 1998), p. 116.

28. Wassily Kandinsky, quoted in Kuspit, "Concerning the Spiritual in Contemporary Art," p. 314.

29. Felix Gonzalez-Torres, "1990: L.A., *The Gold Field*," in *Roni Horn: Earth Grows Thick* (Columbus, Ohio: Wexner Center for the Arts, The Ohio State University, 1996), p. 68.

30. For more on our culture's endemic chromophobia, see David Batchelor, *Chromophobia* (London: Reaktion Books Ltd., 2000).

31. Paul Verlaine, quoted in Bachelard, *The Poetics of Reverie*, p. 9.

32. Katharina Fritsch, quoted in Amanda Zonia, "Art That Goes Bump in the Night," *ARTnews* (November 1996), p. 106.

33. Rosenblum, "Friedrichs from Russia," p. 11.

34. Robert Rosenblum, "Friedrichs from Russia,", p. 15.

35. Bachelard, *The Poetics of Reverie*, p. 25.

36. From Robert C. Morgan, "A Sign of Beauty: For Michael Kirby (1931–1997)," in *Uncontrollable Beauty*, p. 75.

37. Lipsey, *An Art of Our Own*, p. 66.

38. Ralph Waldo Emerson, "Introduction to Nature," 1836, quoted in Hyatt H. Waggoner, *American Poets: From the Puritans to the Present* (Boston: Houghton Mifflin Company, 1968), p. 99.

39. Henri Bergson, quoted in Edward Hirsch, *How to Read a Poem and Fall in Love with Poetry* (Harcourt Brace and Company, New York, 1999), p. 228.

40. Kenneth Baker, "A Use for Beauty," *Artforum* (January 1984), p. 66.

41. Harold Bloom and Lionel Trilling, "Romantic Poetry and Prose," in *The Oxford Anthology of English Literature* (New York: Oxford University Press, 1973), p. 126.

CATALOGUE OF THE EXHIBITION

PLATES

HELEN ALTMAN
Snowhead, 1992
Freezer, snow, and miscellaneous objects
36 x 22 x 22 inches
Courtesy the artist; Dunn and Brown Contemporary, Dallas;
and Moody Gallery, Houston

JAMES LEE BYARS
Slit Moon, 1994
Thassos marble and pedestal
$1^{1}/_{2}$ x $15^{3}/_{4}$ x $1^{1}/_{2}$ inches
Estate of James Lee Byars; courtesy Michael Werner Gallery,
New York

VIJA CELMINS
Ocean Surfaces, 2000
Wood engraving on Zerkall paper
$20^{3}/_{4}$ x $17^{1}/_{4}$ inches
Courtesy McKee Gallery, New York

LYNN DAVIS
Iceberg #5, Disko Bay, Greenland, 1988
Gelatin silver print
28 x 28 inches
Courtesy the artist and Edwynn Houck Gallery, New York

KATHARINA FRITSCH
Totenkopf [Skull], 1997–98
Porcelain and paint
$7^{7}/_{8}$ x $5^{3}/_{4}$ x $9^{7}/_{8}$ inches
Courtesy the artist and Matthew Marks Gallery, New York

ROBERT GOBER
Prison Window, 1992
Plywood, forged iron, plaster, latex paint, and lights
48 x 53 x 36 inches with 24 x 24-inch opening
Courtesy the artist

FELIX GONZALEZ-TORRES
"Untitled" (Aparición), 1991
Offset print on paper, endless copies
8 (at ideal height) x $44^{7}/_{8}$ x $29^{3}/_{4}$ inches
Collection FUNDACION TELEVISA, Mexico City

RODNEY GRAHAM
Oak Tree, Banford, Oxfordshire, England, Fall 1990, 1990
Unique monochrome color print
91 x 72 inches
Collection Emily Fisher Landau, New York

ANN HAMILTON
untitled (privation and excesses), 1989
Metal chair, felt hat, cloth, and honey
$32^{1}/_{2}$ x $18^{1}/_{2}$ x $17^{1}/_{2}$ inches
Collection Mr. and Mrs. Marc Brutten, Delmar, California;
courtesy Sean Kelly Gallery/Projects, New York

HOWARD HODGKIN
Dinner at Palazzo Albrizzi, 1984–88
Oil on wood
$46^{1}/_{2}$ x $46^{1}/_{2}$ inches
Modern Art Museum of Fort Worth; Museum Purchase,
Sid W. Richardson Foundation Endowment Fund, 1988.03.P.P.

JENNY HOLZER
Survival Series: In a dream you saw a way to survive
and you were full of joy
Text: 1983–85; fabrication date 1998
Vermont white marble
17 x 24 x 17 inches
Private collection, Houston

RONI HORN
Gold Field, 1980–82
Pure gold (99.99%)
48 x 60 inches
Courtesy the artist and Matthew Marks Gallery, New York

ANISH KAPOOR
The Healing of St. Thomas, 1989
Fiberglass, plaster, and gouache
Variable dimensions
Museum of Contemporary Art, San Diego; Museum purchase
with funds from the Elizabeth W. Russell Foundation, 1992.4

WOLFGANG LAIB
Untitled (Wachshaus), 1993
Beeswax and wood
22 $1/2$ x 65 x 24 $1/2$ inches
Courtesy the artist and Sperone Westwater, New York

WALTER DE MARIA
High Energy Bar, 1966
Stainless steel
$1^1/2$ x 14 $^1/8$ x $1^1/2$ inches
The Menil Collection, Houston. Gift of the artist

DONALD MOFFETT
#10 (Lot 081200), 2001
Oil on linen
$51^1/2$ x 41 $^1/4$ inches
Private collection

ERNESTO NETO
Glop, 1998
Stocking, styrofoam and ground red pepper
29 x 48 inches in diameter
Courtesy the artist; Tanya Bonakdar Gallery, New York;
and Galeria Camargo, Vilaça, São Paulo

RAYMOND PETTIBON
The sky was very far . . . , 1994
Ink and watercolor on paper
12$^3/4$ x 12$^3/4$ inches
Collection Michael and Eileen Cohen, New York

RACHEL RANTA
Cloud, 1994–2001
Oil on masonite
7 panels; 12 x 9 inches each
Courtesy the artist and Texas Gallery, Houston

CHARLES RAY
Rotating Circle, 1988
Electric motor with 9-inch diameter disk
9 inches in diameter
The Museum of Contemporary Art, Los Angeles;
Gift of Lannan Foundation

GERHARD RICHTER
Fortress at Königstein, 1987
Oil on canvas
20$^1/2$ x 28 $^3/8$ inches
Collection Nancy and Robert Blank;
courtesy James Cohan Gallery, New York

BRIDGET RILEY
Orphean Elegy 5, 1979
Acrylic on linen
55 x 51$^1/2$ inches
Collection Lea and Andy Fastow, Houston

THOMAS RUFF
Stern 11h 16m/–40, 1992
Type C print
102 $^3/8$ x 74 inches
Courtesy the artist and Zwirner & Wirth, New York

QIU SHI-HUA
Untitled, 1996
Oil on canvas
59^{1}/$_{2}$ x 120 inches
Courtesy the artist and Galerie Urs Meile, Lucerne, Switzerland

PAT STEIR
Waterfall des Rêves [Waterfall of Dreams], 1990
Oil on canvas
72 x 48^{1}/$_{4}$ inches
Collection Carol C. Ballard, Houston

NESTOR TOPCHY
Fête Champêtre, 1996
Collage on paper
7^{7}/$_{8}$ x 9^{1}/$_{2}$ inches
Courtesy the artist and Devin Borden Hiram Butler Gallery, Houston

JAMES TURRELL
Zarkov (Magnatron series), 1998
Television
14^{1}/$_{2}$ x 16^{1}/$_{8}$ inches
Courtesy the artist and Devin Borden Hiram Butler Gallery, Houston

BILL VIOLA
The Locked Garden, 2000
Two LCD flat panels with DVD playback equipment and DVD; 15-minute loop
16^{1}/$_{4}$ x 26^{1}/$_{8}$ x 6^{1}/$_{2}$ inches
Collection Marguerite and Robert Hoffman, Dallas

ROBERT WILSON
Blue Geese, 1994
Papier maché, plaster, and feathers
Three geese, 10 x 60 x 40 inches each
Courtesy the artist; Paula Cooper Gallery, New York; and Hiram Butler Devin Borden Gallery, Houston

HELEN ALTMAN

Snowhead, 1992

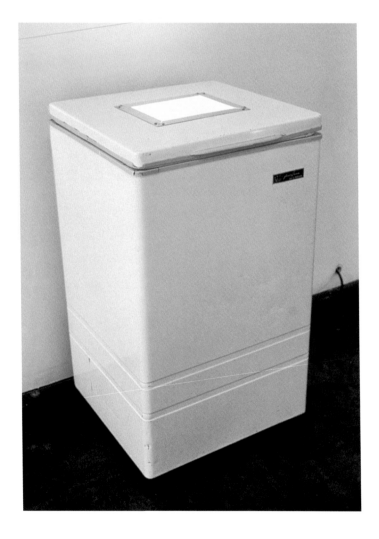

Freezer, snow, and miscellaneous objects
36 x 22 x 22 inches
Courtesy the artist; Dunn and Brown Contemporary,
Dallas; and Moody Gallery, Houston

JAMES LEE BYARS

Slit Moon, 1994

Thassos marble and pedestal
$1^1/2$ x $15^3/4$ x $1^1/2$ inches
Estate of James Lee Byars; courtesy Michael
Werner Gallery, New York

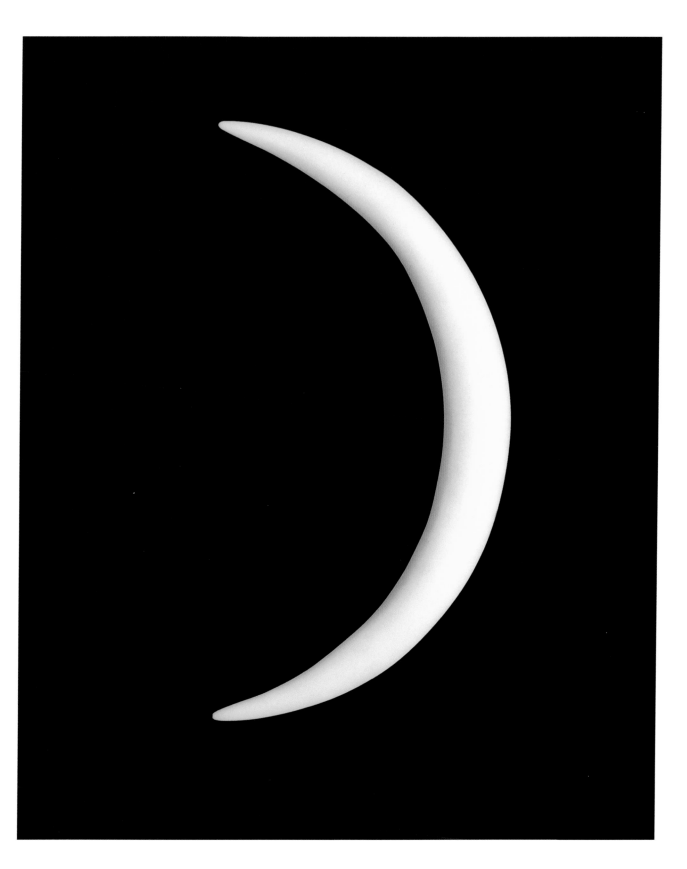

VIJA CELMINS

Ocean Surfaces, 2000

Wood engraving on Zerkall paper
20 3/4 x 17 1/4 inches
Courtesy McKee Gallery, New York

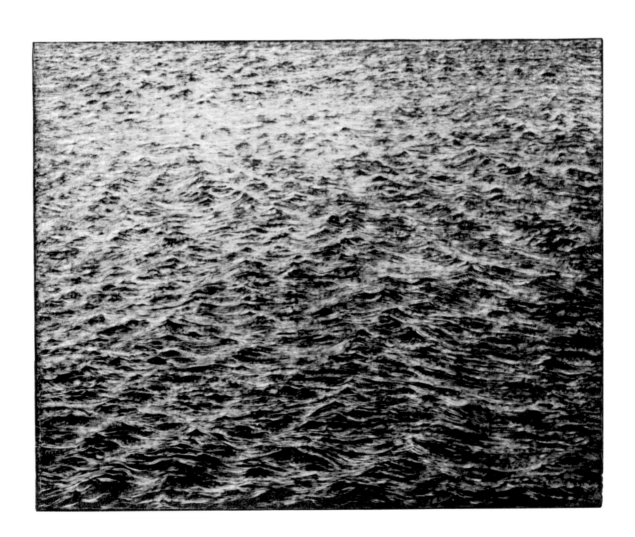

LYNN DAVIS

Iceberg #5, Disko Bay, Greenland, 1988

Gelatin silver print
28 x 28 inches
Courtesy the artist and Edwynn Houck
Gallery, New York

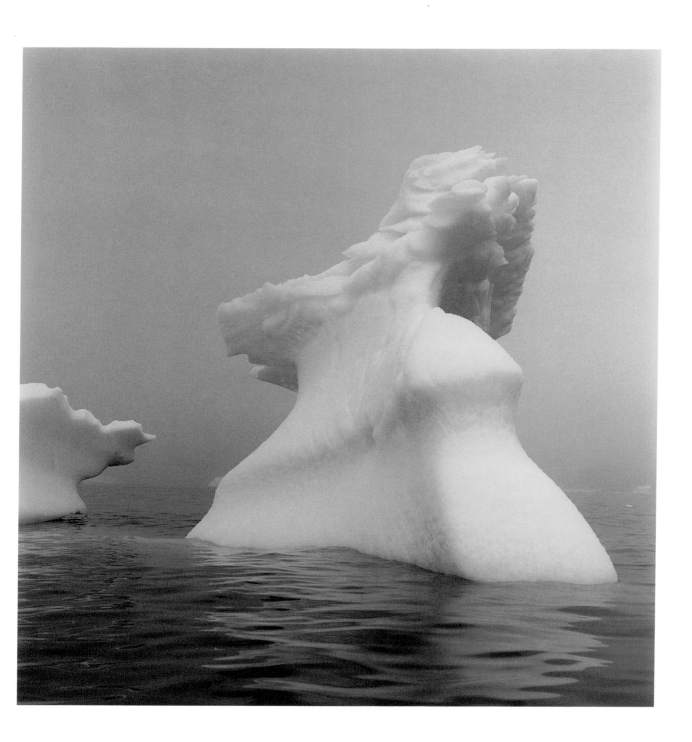

KATHARINA FRITSCH

Totenkopf [Skull], 1997–98

Porcelain and paint
7 7/8 x 5 3/4 x 9 7/8 inches
Courtesy the artist and Matthew Marks
Gallery, New York

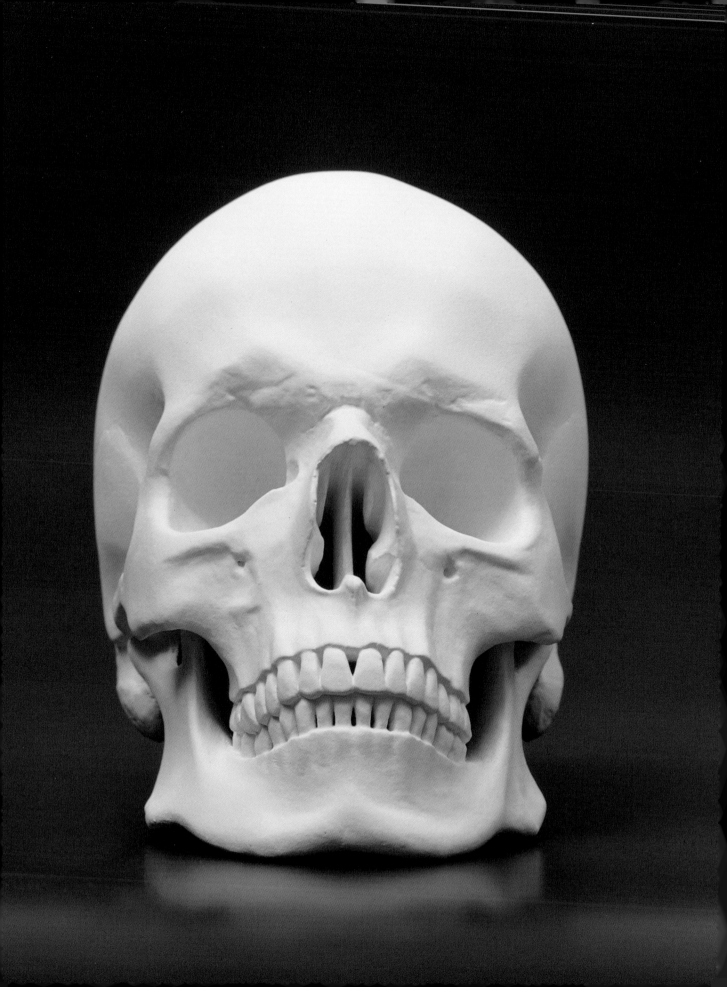

ROBERT GOBER

Prison Window, 1992

Plywood, forged iron, plaster, latex paint, and lights
48 x 53 x 36 inches with 24 x 24-inch opening
Courtesy the artist

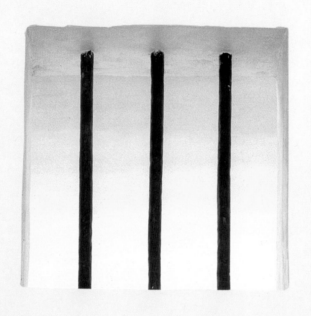

FELIX GONZALEZ-TORRES

"Untitled" (Aparición), 1991

Offset print on paper, endless copies
8 (at ideal height) x 44 ⁷/₈ x 29 ³/₄ inches
Collection FUNDACION TELEVISA, Mexico City

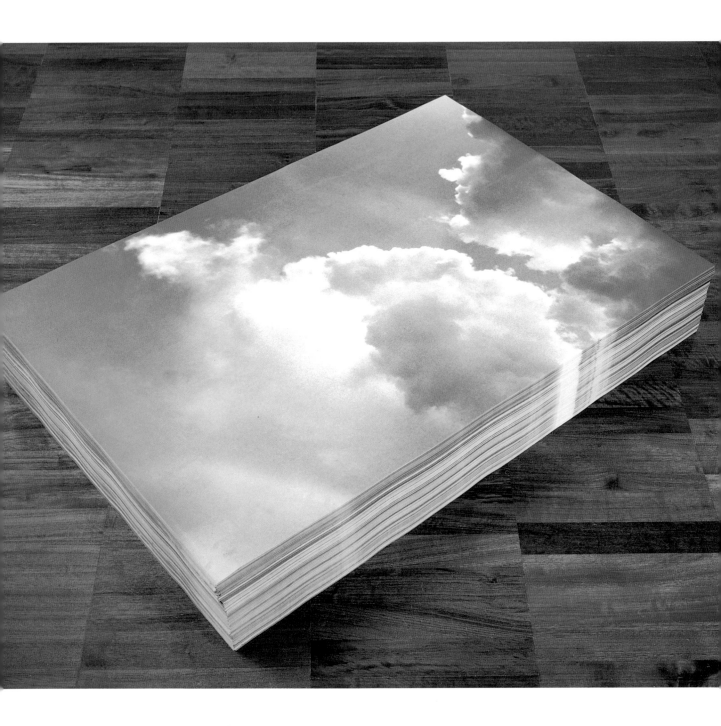

RODNEY GRAHAM

Oak Tree, Banford, Oxfordshire, England, Fall 1990, 1990

Unique monochrome color print
91 x 72 inches
Collection Emily Fisher Landau, New York

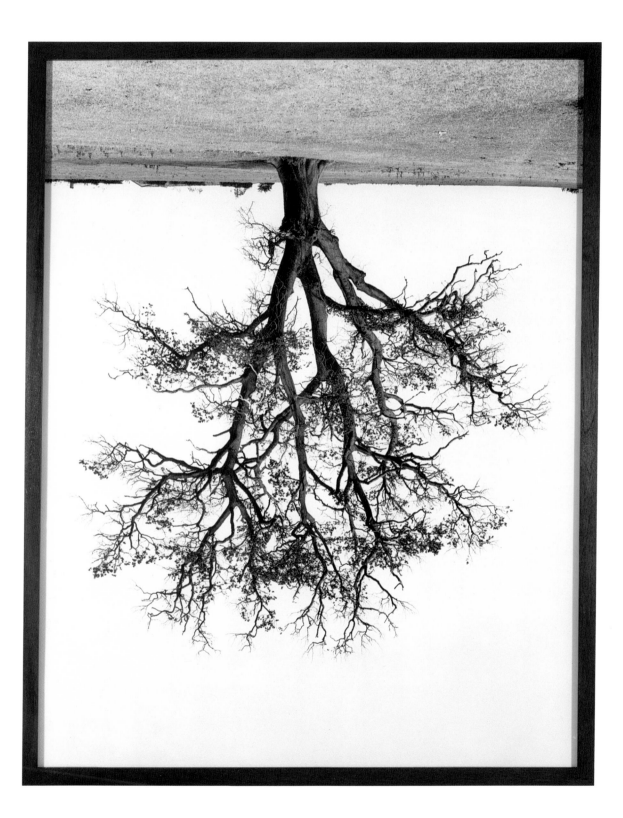

ANN HAMILTON

untitled (privation and excesses), 1989

Metal chair, felt hat, cloth, and honey
32 1/2 x 18 1/2 x 17 1/2 inches
Collection Mr. and Mrs. Marc Brutten, Delmar, California;
courtesy Sean Kelly Gallery/Projects, New York

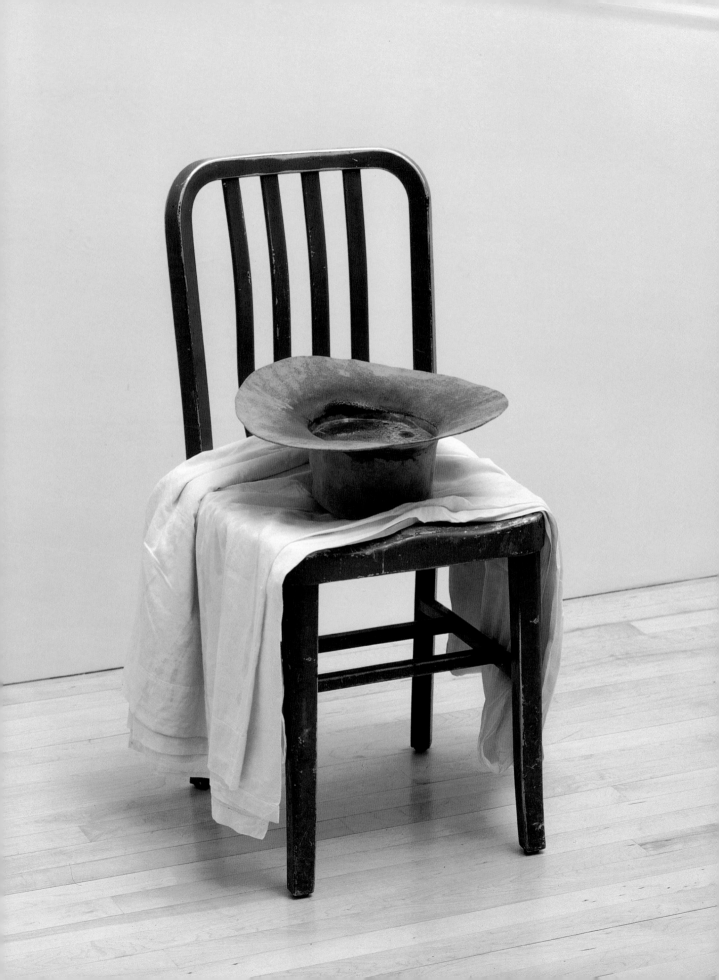

HOWARD HODGKIN

Dinner at Palazzo Albrizzi, 1984–88

Oil on wood
46 1/2 x 46 1/2 inches
Modern Art Museum of Fort Worth; Museum Purchase, Sid
W. Richardson Foundation Endowment Fund, 1988.03.P.P.

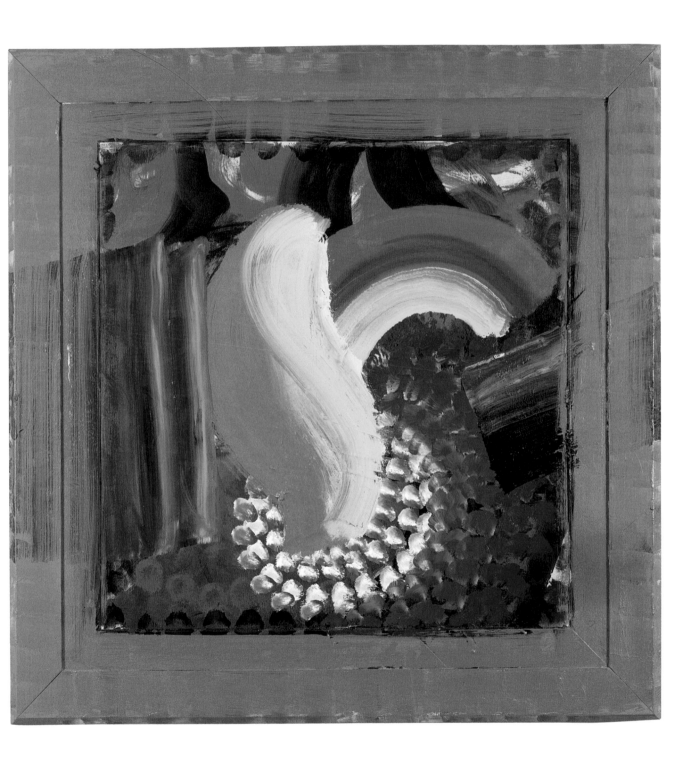

JENNY HOLZER

Survival Series:
In a dream you saw a way to survive
and you were full of joy

Text: 1983–85; fabrication date 1998
Vermont white marble
17 x 24 x 17 inches
Private collection, Houston

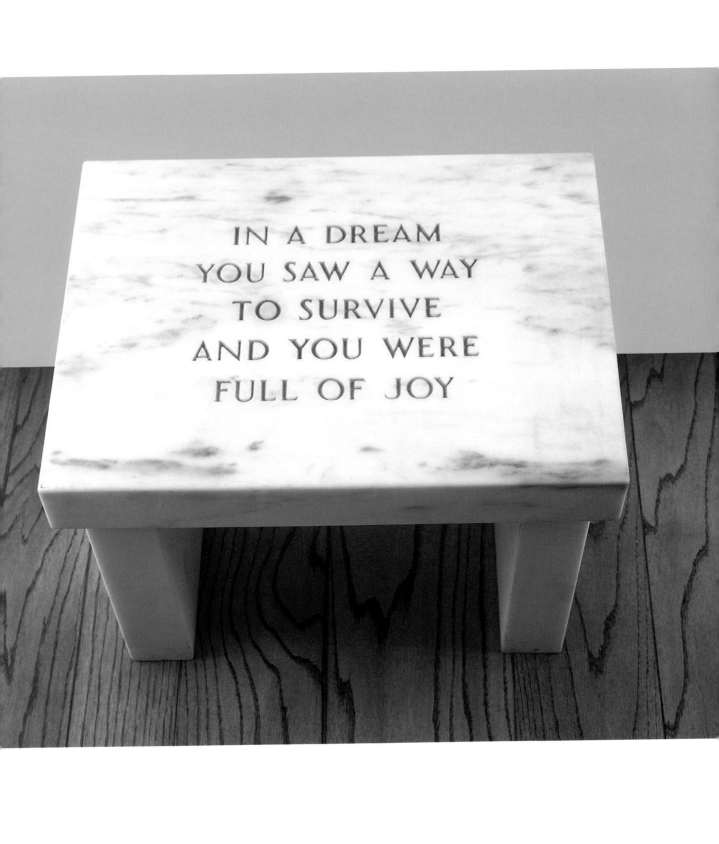

RONI HORN

Gold Field, 1980–82

Pure gold (99.99%)
48 x 60 inches
Courtesy the artist and Matthew Marks Gallery,
New York

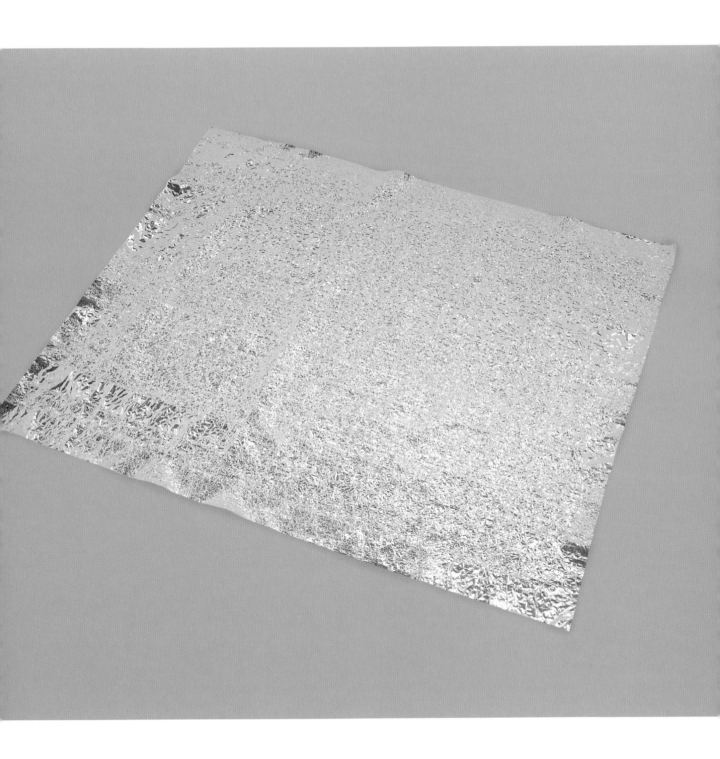

ANISH KAPOOR

The Healing of St. Thomas, 1989

Fiberglass, plaster, and gouache
Variable dimensions
Museum of Contemporary Art, San Diego; Museum purchase
with funds from the Elizabeth W. Russell Foundation, 1992.4

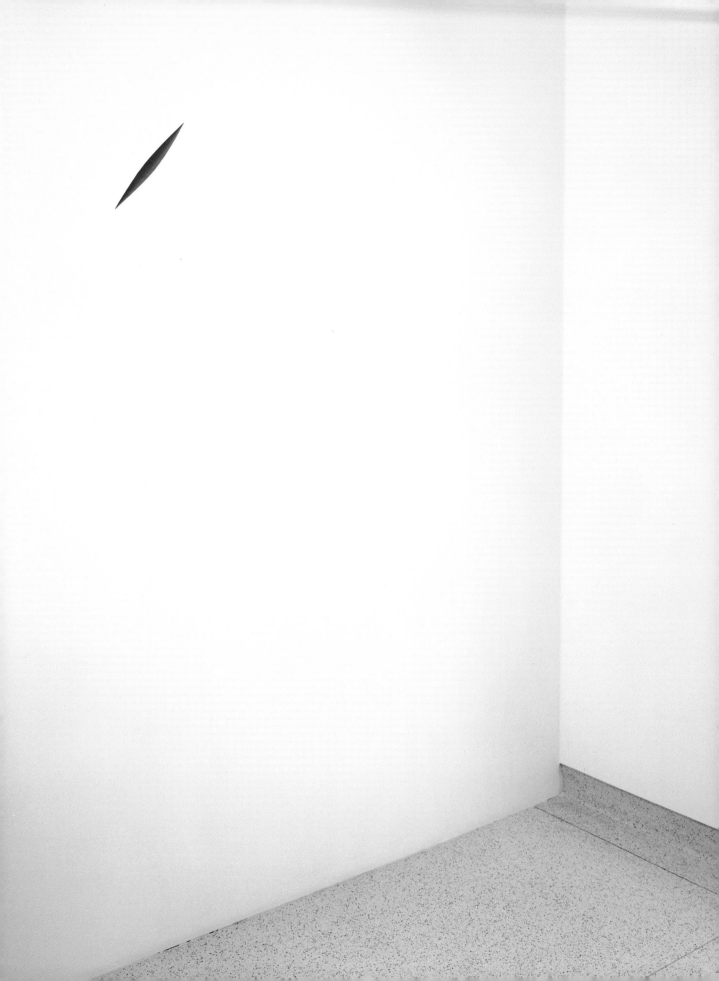

WOLFGANG LAIB

Untitled (Wachshaus), 1993

Beeswax and wood
22 1/2 x 65 x 24 1/2 inches
Courtesy the artist and Sperone Westwater, New York

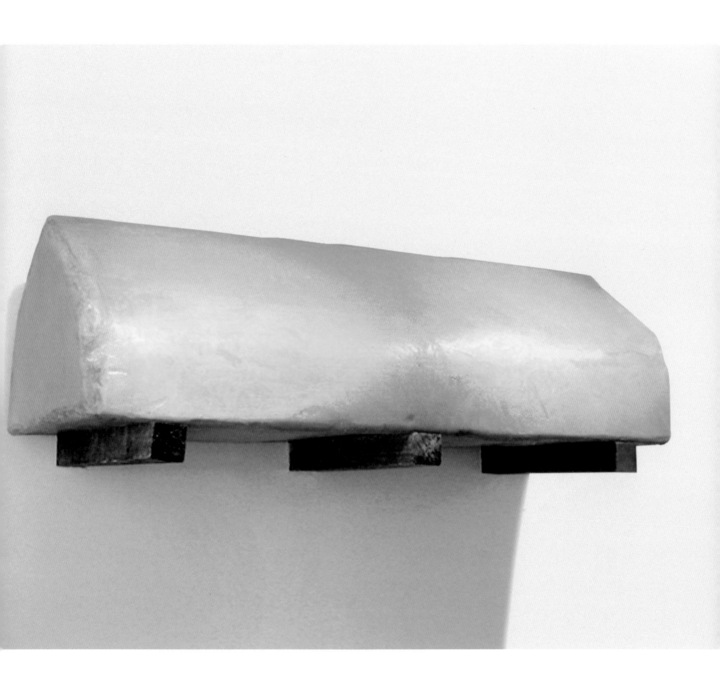

WALTER DE MARIA

High Energy Bar, 1966

Stainless steel
$1^1/_2$ x $14^1/_8$ x $1^1/_2$ inches
The Menil Collection, Houston. Gift of the artist

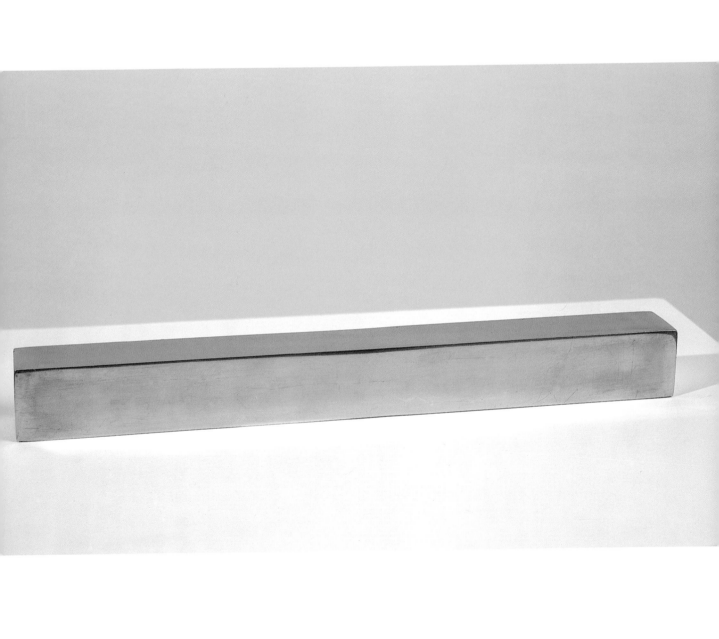

DONALD MOFFETT

#10 (Lot 081200), 2001

Oil on linen
51^{1}/$_{2}$ x 41^{1}/$_{4}$ inches
Private collection

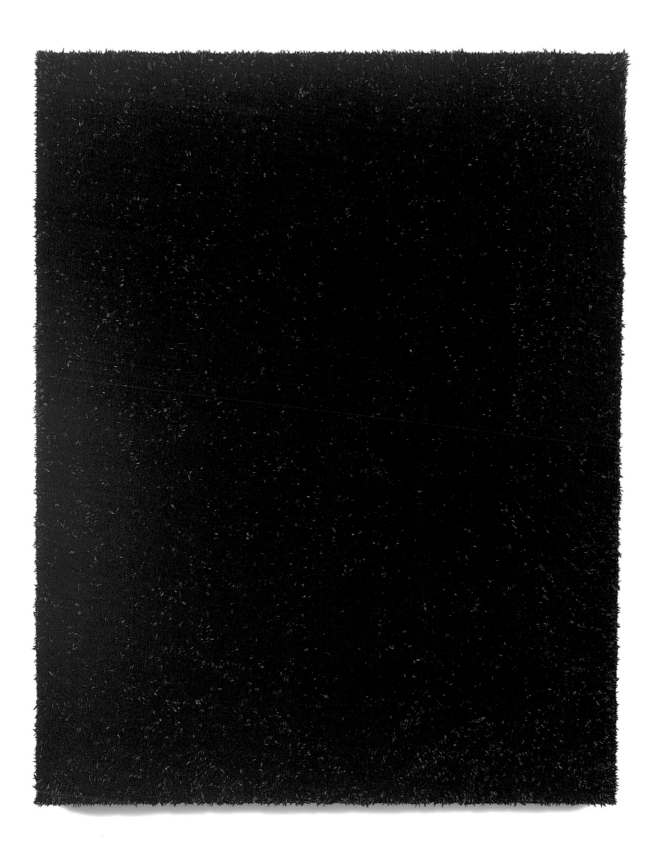

ERNESTO NETO

Glop, 1998

Stocking, styrofoam and ground red pepper
29 x 48 inches in diameter
Courtesy the artist; Tanya Bonakdar Gallery, New
York; and Galeria Camargo Vilaça, São Paulo

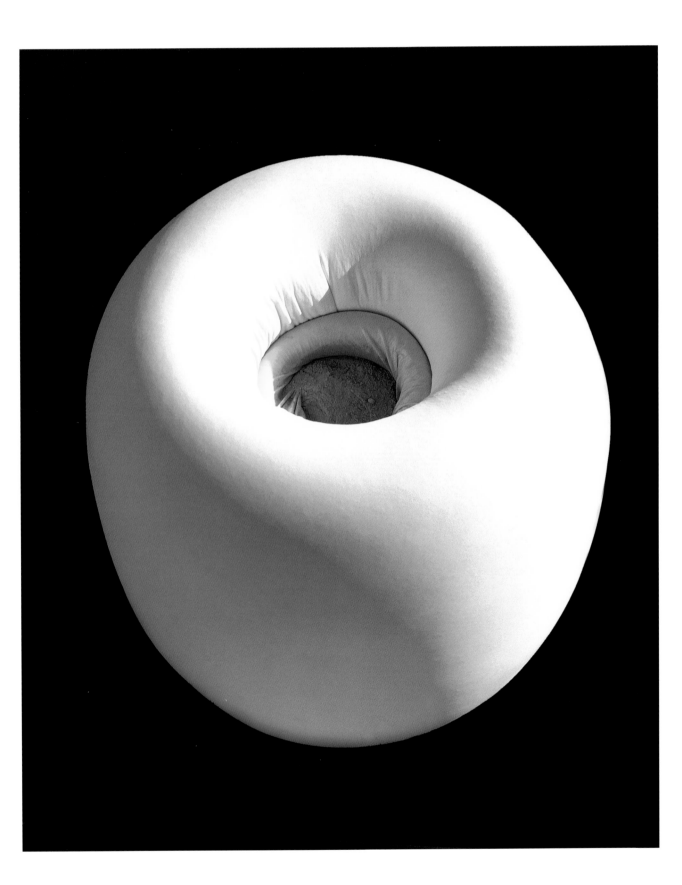

RAYMOND PETTIBON

The sky was very far..., 1994

Ink and watercolor on paper
12³/4 x 12³/4 inches
Collection Michael and Eileen Cohen, New York

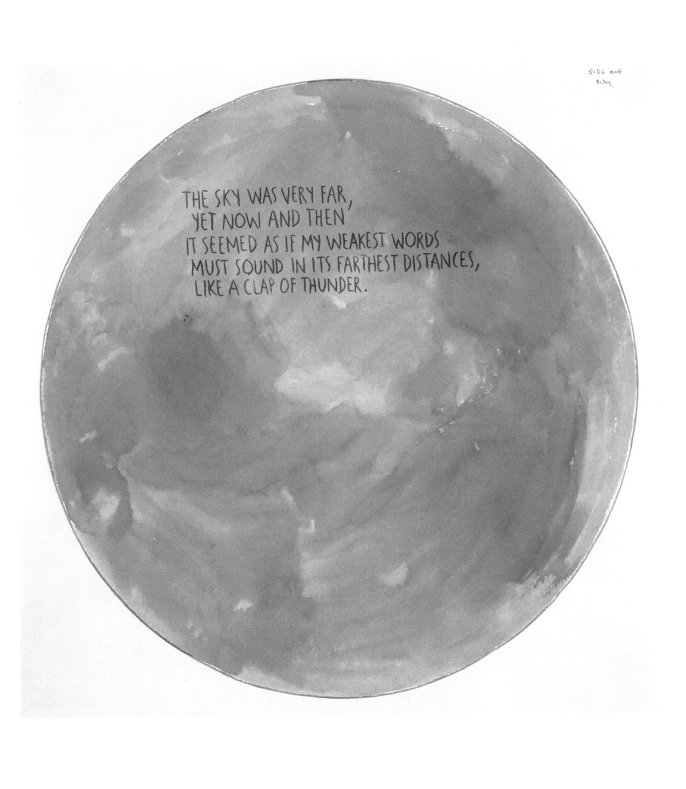

THE SKY WAS VERY FAR,
 YET NOW AND THEN
IT SEEMED AS IF MY WEAKEST WORDS
 MUST SOUND IN ITS FARTHEST DISTANCES,
 LIKE A CLAP OF THUNDER.

QIU SHI-HUA

Untitled, 1996

Oil on canvas
59¹/₂ x 120 inches
Courtesy the artist and Galerie Urs Meile,
Lucerne, Switzerland

RACHEL RANTA

Cloud, 1994–2001

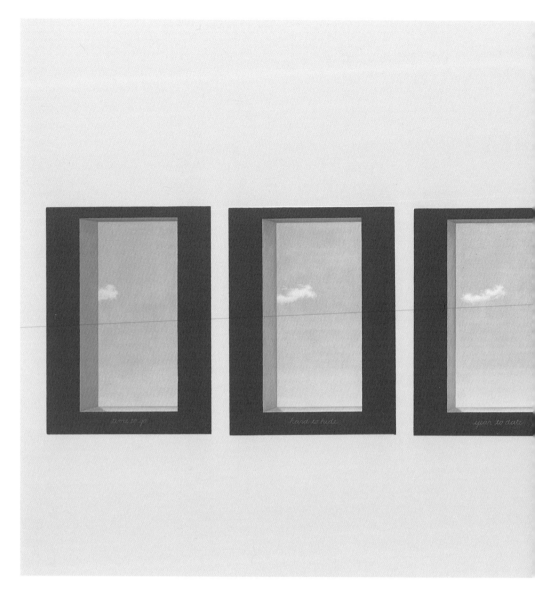

Oil on masonite
7 panels; 12 x 9 inches each
Courtesy the artist and Texas Gallery, Houston

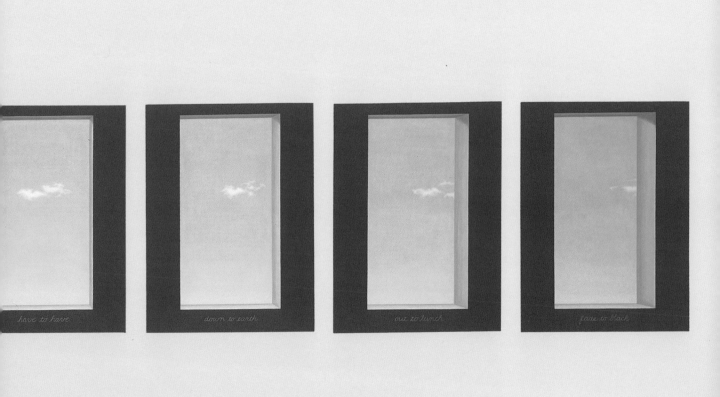

CHARLES RAY

Rotating Circle, 1988

Electric motor with 9-inch diameter disk
9 inches in diameter
The Museum of Contemporary Art, Los Angeles;
Gift of Lannan Foundation

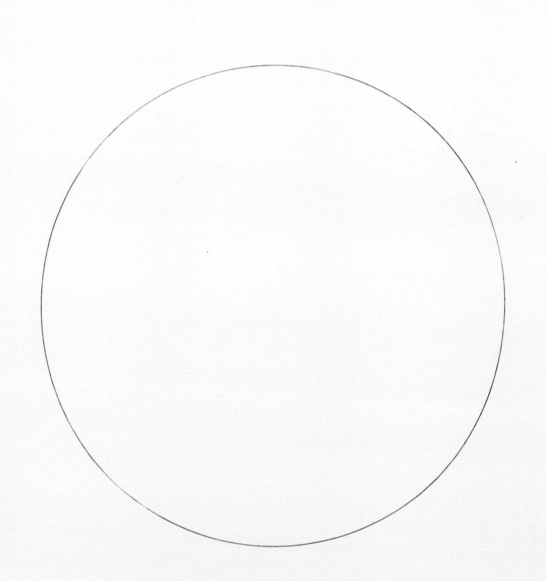

GERHARD RICHTER

Fortress at Königstein, 1987

Oil on canvas
20 1/2 x 28 3/8 inches
Collection Nancy and Robert Blank;
courtesy James Cohan Gallery, New York

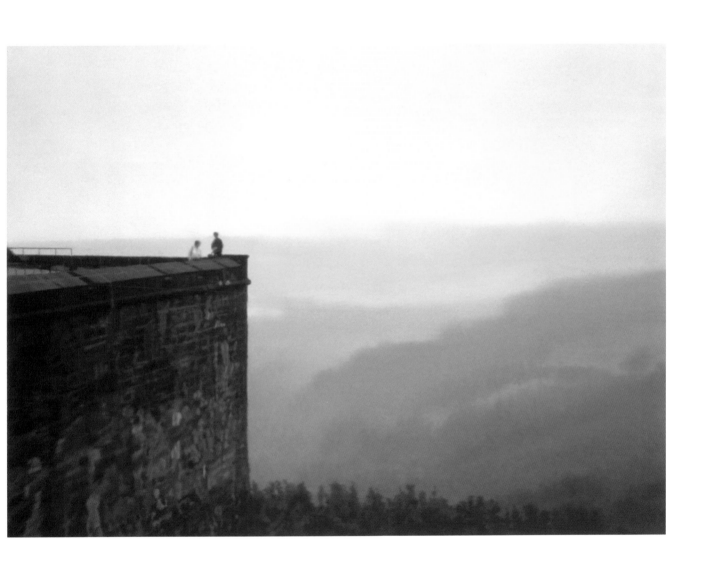

BRIDGET RILEY

Orphean Elegy 5, 1979

Acrylic on linen
55 x 51^{1}/2 inches
Collection Lea and Andy Fastow, Houston

THOMAS RUFF

Stern 11h 16m/– 40, 1992

Type C print
102 3/8 x 74 inches
Courtesy the artist and Zwirner & Wirth, New York

PAT STEIR

Waterfall des Rêves [Waterfall of Dreams], 1990

Oil on canvas
72 x 48 1/4 inches
Collection Carol C. Ballard, Houston

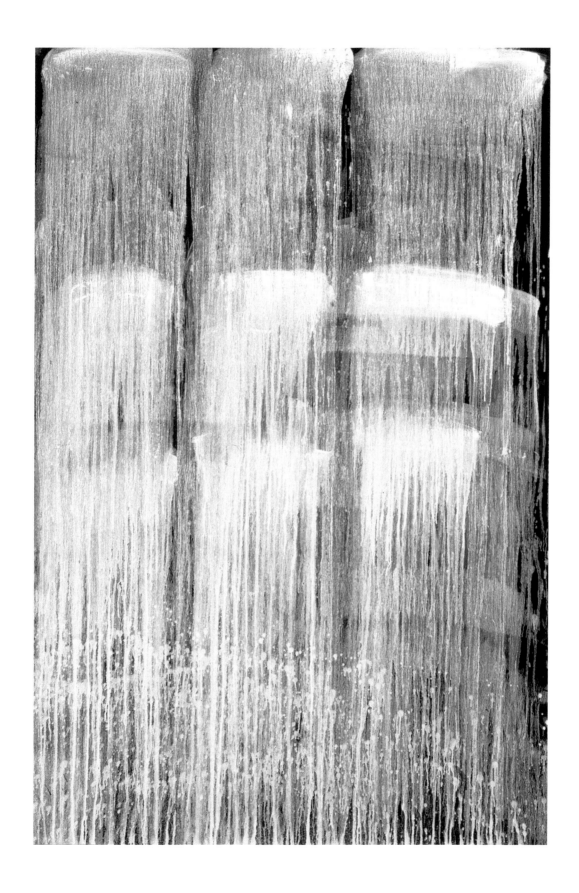

NESTOR TOPCHY

Fête Champêtre, 1996

Collage on paper
7 7/8 x 9 1/2 inches
Courtesy the artist and Devin Borden Hiram Butler
Gallery, Houston

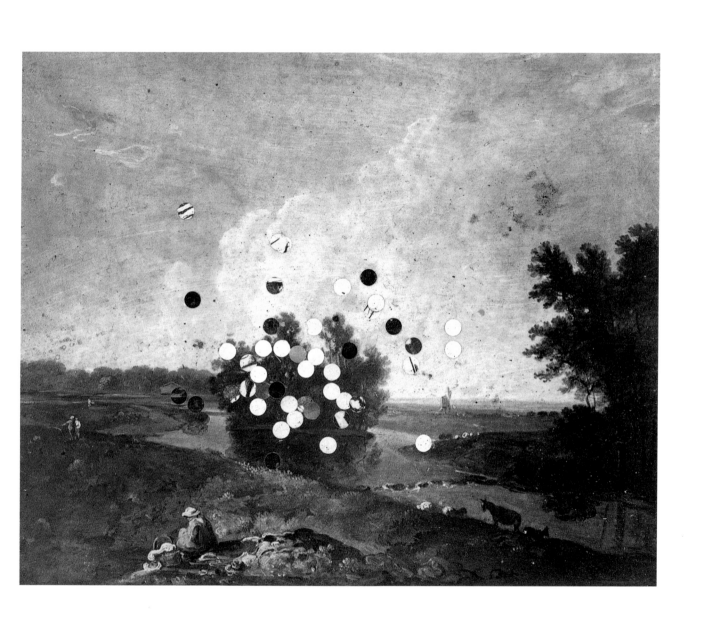

JAMES TURRELL

Zarkov (Magnatron series), 1998

Television
14 1/2 x 16 1/8 inches
Courtesy the artist and Devin Borden Hiram Butler
Gallery, Houston

BILL VIOLA

The Locked Garden, 2000

Two LCD flat panels with DVD playback equipment
and DVD; 15-minute loop
16 1/4 x 26 1/8 x 6 1/2 inches
Collection Marguerite and Robert Hoffman, Dallas

ROBERT WILSON

Blue Geese, 1994

Papier maché, plaster, and feathers
Three geese, 10 x 60 x 40 inches each
Courtesy the artist; Paula Cooper Gallery, New York;
and Hiram Butler Devin Borden Gallery, Houston

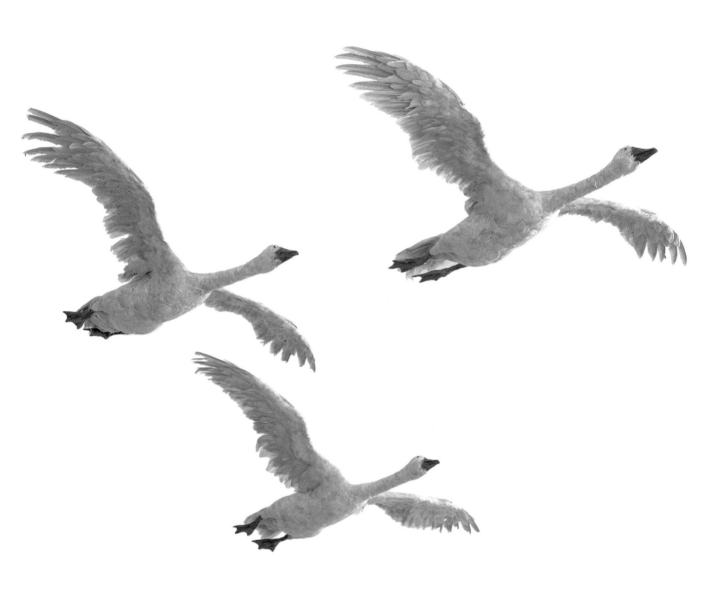

n my experience, an onset of beauty combines extremes of stimulation and relaxation. My mind is hyperalert. My body is at ease. Often I am aware of my shoulders coming down as unconscious muscular tension lets go. My mood soars. I have a conviction of goodness in all things. I feel that everything is going to be all right. Later I am pleasantly a little tired all over, as after swimming.

Mind and body become indivisible in beauty. Beauty teaches me that my brain is a physical organ and that "intelligence" is not limited to thought, but entails feeling and sensation, the whole organism in concert. Centrally involved is a subtle activity of hormonal excitation in or about the heart—the muscular organ, not a metaphor.

Beauty is a willing loss of mental control, surrendered to organic process that is momentarily under the direction of an exterior object. The object is not thought and felt about, exactly. It seems to use my capacities to think and feel itself.

Beauty is never pure for me. It is always mixed up with something else, some other quality or value—or story, even, in rudimentary forms of allegory, "moral," or "sentiment": Nothing in itself, beauty may be a mental solvent that dissolves something else, melting it into radiance.

Beauty invariably surprises me even when I am looking at what I assume to be beautiful—a sunset, say, or a painting by Giovanni Bellini. There is always a touch of strangeness and novelty about it, an element that I did not expect. The element is usually very simple and overwhelming. In the sunset, I may identify something I never realized before about color; in the Bellini, something about mercy.

Sometimes the object of beauty is not just unexpected, but bizarre, with an aspect I initially consider odd or even ugly. Such experiences are revolutions of taste, insights into new or alien aesthetic categories. When I first "got" an Indian temple sculpture, it was as if my molecules were violently rearranged. Something similar happened when I first "got" a painting by Jackson Pollock, say, or Andy Warhol—any strongly innovative artist. As a rule, what had seemed most odd or ugly became the exact trigger of my exaltation.

An experience of beauty may be intense, leaving a permanent impression, or quite mild and soon all but forgotten. But it always resembles a conversion experience, the mind's joyful capitulation to a recovered or new belief. The merely attractive (pretty, glamorous) and merely pleasing (lovely, delectable) are not beauty, because they lack the element of belief and the feeling of awe that announces it.

The attractive or pleasing enhances the flow of my feelings. The beautiful halts the flow, which recommences in a changed direction.

Beauty entails a sense of the sacred. It surrounds something with an aura of inviolability, a taboo on violation. I am mightily attracted to the object while, by a countervailing and equal force of reverence, held back from it. I am stopped in my tracks, rooted to the spot. Beauty is a standoff.

Beauty has an equivocal relation with taste, which at best guides me to things I will like and at worst steers me away from things I might like if I gave them a chance. Taste may sharpen beauty by putting up an initial resistance to its object, making keener the moment when my intellect lays down its arms in surrender. Taste that is not regularly overridden forms a carapace, within which occurs spiritual asphyxiation. But to have no taste at all is to have retained nothing from aesthetic experience. Taste is residue of beauty.

In line with recent breakthroughs in neurological brain research, I fancy that one day the mental event that is an experience of beauty will be X-ray photographed. I predict that the photograph will show the brain lit up like a Christmas tree, with simultaneous firings of neurons in many parts of the brain, though not very brightly. It will show a suddenly swelling diffused glow that wanes gradually. There is something crazy about a culture in which the value of beauty becomes controversial. It is crazy not to celebrate whatever reconciles us to life. The craziness suggests either stubborn grievance—an unhappiness with life that turns people against notions of reconciliation to it—or benumbed insensibility. The two terms may be one.

"Beauty" versus beauty. Platitude versus phenomenon. Term of sentimental cant versus dictionary word in everyday use. I want to rescue for educated talk the vernacular sense of beauty from the historically freighted, abstract piety of "Beauty."

A dictionary says beauty is "the quality present in a thing or person that gives intense pleasure or deep satisfaction to the mind." Now, the idea of a "quality present in" external reality could use qualifying in this case. Overly confident identifying of experience with its object can foster rigid projections, such as "Beauty," that repulse the playful, exploratory, even skeptical vitality of aesthetic perception. Speech should distinguish beauty as a quality more volatile than, say, the color blue. The sky's reputation of being

blue has never yet, that I know of, incited a rebellious conviction that it is orange. But anything's reputation of being beautiful is guaranteed to recommend itself to some as a theory, if not of the ugly, of the boring. To argue that beauty is real is unnecessary. To argue that it is interesting requires making room for the position that it is "all in the mind."

Meanwhile, can there be any possible problem with "intense pleasure or deep satisfaction to the mind"? I know those experiences, and I like them. I believe that others know and like them, too. For people without the comfort of religion, and even for many who are religious, the experiences may provide a large part of what makes life worth living. Any society that does not respect the reality of "intense pleasure and deep satisfaction to the mind" is a mean society. Respect for something begins with having a respectful name for it.

Many of us talk too little about our delights and accord other people's delights too little courtesy. This is especially so in these days of moralistic attack on things that make life tolerable for many: a cigarette and a drink, even, to ease someone's passage—perhaps also to shorten the passage, but that is no one else's business. Beauty, too, is an intoxicant. So, too, is moralism, if moralizers would only admit it. Baudelaire said it best: "Always be drunk. Get drunk constantly—on wine, on poetry, or on virtue, as you prefer." Today many people drunk on virtue harass people who prefer wine or poetry. You can't argue with the harassers, of course. You can't argue with drunks.

No one is without experiences of beauty. "You can live three days without food," Baudelaire wrote. "Without poetry, never." By poetry, I think he meant beauty in its thousand forms and tinctures, some of them common to all lives. "Fucking is the poetry of the masses," he said by way of amplification.

Moralizers take as their business the pronouncement of who gets to take pleasure when, where, how, and in what. The very word *pleasure* can be embattled now. I read an intellectual debate somewhere in which someone defended a respect for popular culture on the basis that it is pleasurable. To which someone else objected, "So is heroin." I suppose the objector meant that popular culture is an opiate of the people. He was one of those who think the people should not have opiates.

Socially invested "Beauty" has sins to answer for. (I recall a little usage lesson from my childhood: "Women are beautiful; men are handsome.") But the idea of beauty need not be imprisoned by its former uses. Indeed, the conviction of timelessness that is instilled by beauty recommends that the word constantly be shorn of period-and-place-specific connotations, even as it constantly takes on new ones.

The notion of anything being "timeless" is rationally absurd. But such is the lived sense of beauty, which Baudelaire identified as a flash point between the fleeting and the eternal. This is a healthy absurdity, which makes palpable the limits of thought's poky categories. Baudelaire stumbled upon it everywhere. In 1846, he noted the fashion of the black frock coat, whose "political virtues" as a symbol of democratic leveling were not inconsistent with its "poetic beauty, which is the expression of the public soul—an immense procession of undertakers' mourners, political mourners, mourners in love,

bourgeois mourners. All of us are attending some funeral or other."

Anyone who cannot find an analogous poetry when surveying the parade of a contemporary street is an unfortunate person.

Do experiences of beauty today fall within the purview and function of art? Not necessarily, and certainly not all the time.

Forty or so years ago, J. L. Austin wrote that it was time for aesthetics to quit fretting about the single narrow quality of the beautiful. He recommended for study the dainty and the dumpy. Though without intending to be, he was prophetic. Since pop art, minimalism, arte povera, and conceptualism, artists have devoted themselves to all manner of aesthetic sensations exclusive of beauty—to the point where it seems vital to think about beauty again, though hardly to reduce the focus of the aesthetic back to beauty alone.

Loss of necessary connection between beauty and art seems another of the baleful effects of modern technology, which can simulate, so readily and in such abundance, experiences that once were hard to come by. Visual beauty has been escaping from visual art into movies, magazines, and other media, much as the poetic has escaped from contemporary poetry into popular songs and advertising.

Beauty's value as a profound comfort, a reconciliation with life, inevitably wanes when ordinary life is replete with comforts, notably including less frequent exposure to the ugly. The beautiful meant more before indoor plumbing.

Another reason for the progressive divorce of beauty from art is the institutional order that governs most activities involving art. Servants of this order, like minions of an established church, naturally try to rationalize their functions. They are temperamentally averse to irrational and, especially, indescribable phenomena. If I had what I believed was a mystical experience, probably the last person I would report it to would be a priest or pastor. Similarly, I do not discuss beauty with curators. It would only discomfit them and embarrass me.

Anyone can tolerate only so much beauty. Some years ago, a doctor in Florence announced his discovery of the "Stendhal Syndrome," named after the French writer. Stendhal had reported a kind of nervous breakdown after a spell of looking at masterpieces of Renaissance art. The doctor noted a regular occurrence of the same symptoms of disorientation—ranging, at the extreme, to hallucinations and fainting—in tourists referred to him as patients. For treatment, the doctor prescribed rest indoors with no exposure to art. It occurs to me that contemporary art is hygienic in this regard. I have never had the slightest touch of the Stendhal Syndrome at a Whitney Biennial.

Beauty is not to be recommended for borderline personalities. It is perhaps most to be recommended for those who, quite sane, most resist the notion of surrendering

mental control, such as certain intellectuals who insult aesthetic rapture as "regressive." They should come off it. The self you lose to beauty is not gone. It returns refreshed. It does not make you less intelligent. It gives you something to be intelligent about.

Entirely idiosyncratic, perverse, or otherwise flawed experiences of beauty may be frequent. There is nothing "wrong" about them, and the distinction between them and "real" experiences of beauty is murky (requiring quotation marks). Unusual experiences may constitute a pool of mutations, most of them inconsequential, but some fated to alter decisively a familiar form. Of course, such alteration, like the distinction between familiar and mutant beauty, is moot unless a cultural sphere exists in which subjective experiences are openly revealed, compared, and debated.

An experience of beauty entirely specific to one person probably indicates that the person is insane.

"Beauty is Truth, Truth Beauty"? That's easy. Truth is a dead stop in thought before a proposition that seems to obviate further questioning, and the satisfaction it brings is beautiful. Beauty is a melting away of uncertainty in a state of pleasure, which when recalled to the mind bears the imprimatur of truth. I do demur at Keats's capitalization. Truth and beauty are time-bound events. Truth exists only in the moment of the saying of a true thing, and beauty exists only in the moment of the recognition of a beautiful thing. Each ceases to exist a moment later, though leaving a trace.

Are there canons of beauty and truth? There are. Everybody has one, whether consciously or not. In social use, canons are conventionalized imaginary constructs of quality and value which, at both best and worst, are abstract rating games for adepts of this or that field of the mind. Battles over canons should be passionate and fun. Something is wrong if they are not fun. Usually the cause of the disagreeableness is a power struggle in disguise.

Nothing makes for worse art and more trivial politics simultaneously than *Kulturkampf*, a symbolic fight over symbols. Art is given misplaced concreteness as the bearer of realities it is taken to symbolize. Politics become fanciful. Righteous blows are struck at air.

Quality. We need this word back, too. It has been abused by those who vest it with transcendent import, rendering it less a practical-minded rule of thumb than an incantation. Quality is a concept of humble and limited, but distinct, usefulness. It is the measure of something's soundness, its aptness for a purpose. I want a good-quality picture to hang on my wall and a good-quality wall to hang my picture on. I will be the judge of what sort of quality—or, better, what combination of qualities—is appropriate. I will be delighted to discuss my judgment with you, and you may enjoy the discussion, too, so long as I refrain from suggesting that my preference somehow puts you in the wrong.

In matters of quality, aptness is all. The best airplane is no match for the worst nail file when your nails want filing. Meanwhile, there is also an order of quality pertaining

to purposes in themselves. It does not matter how well something is done if it is not worth doing, or if to do it is evil.

Much resistance to admitting the reality of beauty may be motivated by disappointment with beauty's failure to redeem the world. Experiences of beauty are sometimes attended by soaring hopes, such as that beauty must some day, or even immediately, heal humanity's wounds and rancors. It does no such thing, of course.

Much resistance to the reality of truth suggests a potential of truths that the resister fears.

Much resistance to the reality of quality, as a measure of fulfilled purpose, bespeaks the condition of people who either lack a sense of purpose or whose purposes must, by their nature, be dissembled.

Insensibility to beauty may be an index of misery. Or it may reflect wholehearted commitment to another value, such as justice, whose claims seem more urgent.

When politics is made the focus of art, beauty does not wait to be ousted from the process. Beauty deferentially withdraws, knowing its place. Beauty is not superfluous, not a luxury, but it is a necessity that waits upon the satisfaction of other necessities. It is a crowning satisfaction.

I. THE WORLD AS PICTURE

What is a world picture? Obviously a picture of the world. But what does "world" mean here? What does "picture" mean? World serves here as a name for what it is in its entirety. The name is not limited to the cosmos, to nature. History also belongs to the world. . . . World picture, when understood essentially, does not mean a picture of the world but the world conceived and grasped as picture. What is, in its entirety, is now taken in such as way that it first is in being and only in being to the extent that it is set up by man.

—Martin Heidegger, *The Age of the World Picture*

We see, then, why we must speak of a structuralist *activity*: creation or reflection are not, here, an original "impression" of the world, but a veritable fabrication of a world which resembles the first one, not in order to copy it but to render it intelligible.

—Roland Barthes, *The Structuralist Activity*

Martin Heidegger envisioned the emergence of a "world picture" as the fundamental event of the modern age. In the modern age humankind has become "subject"—the originator of its own fate. No longer is the world perceived as created by an outside divine power, such as the Creator-God depicted in the outer panels of Hieronymus Bosch's *Garden of Earthly Delights* (c. 1504), looking down from above at the world hovering inside a crystalline globe on the third day of Creation. Rather, the world is conceived from within by human self-consciousness. For Heidegger, the foremost manifestation of humanity's new being-as-subject is modern science.

During the course of the twentieth century, quantum theory and structuralism became defining powers for representing the world in, respectively, science and philosophy; both, in my view, will continue to do so, at least until the so-called unified theory, which has eluded theoretical physicists for more than sixty years, finally combines general relativity with quantum theory and brings about a new "world picture." Quantum theory and structuralism emerged almost simultaneously during the first twenty-six years of the twentieth century (in fact, Ferdinand de Saussure's *Course in General Linguistics* of 1916 was published the same year that Albert Einstein's theory of general relativity was finalized).

Quantum theory introduced into physics the problem of the observer (and therewith the "world picture"). Structuralism focused on *activity*, on what we *do* rather than on what *is*. Just as quantum theory is more concerned with the experiment than with its outcome, structuralism is concerned with the fabrication of meaning rather than meaning itself. Both insist on an immanent analysis, which is located within a system—whether the universe or a work of art.

Here I loosely follow the classic introduction to structuralism, *The Structuralist Activity*, by the French essayist and literary critic Roland Barthes, as well as a recent publication by the theoretical physicist Lee Smolin, *The Life of the Cosmos*. Barthes cites two principal operations that define structuralism, which also seem applicable to quantum theory: dissection and articulation. Dissection involves identifying elementary units of a system that, though not actually bearing meaning themselves, are involved in the attribution of meaning, such as letters in a word or particles in quantum physics. Articulation involves recomposing these elementary units into what Barthes calls a simulacrum of the system (a world picture) in order to reveal the rules of their functioning. Quantum physicists would call this recomposition the quantum state of a system, the construction into which the information we observe about the world is coded.

In 1927 the German physicist and philosopher Werner Heisenberg published his indeterminacy, or uncertainty, principle, upon which he then built his philosophy and for which he is best known. It states that it is intrinsically impossible for one observer located within a system to give a complete description of that system: a single observer can never view or learn more than fifty percent of the world to which he or she belongs. In response, quantum physicists have suggested a community of observers who would be able to collect a participatory world picture comprising a multiplicity of world views.

The impossibility of ever attaining a complete description of the world through a

single human or superhuman intelligence is at the root of the modern concept of a "world picture" and its break with the notion that art is "representational." One might say, in fact, that the modern crisis of representation is the essence of this world picture. Paradoxically, the possibility of a world picture at the same time brings with it the impossibility of representing the world as picture.

As the new millennium unfolds, no new, revolutionary pictorial inventions are likely to emerge. Instead, as in quantum physics, much of recent art has been deeply engaged in a structuralist analysis of our world and in a new participatory humanism—in a renewed involvement in the question of being and transcendence.

II. FROM THE TRANSCENDENTAL TO THE SOCIAL

> If transcendence has meaning, it can only signify the fact that the *event of being*, the *esse*, the *essence*, passes over to what is other than being. . . . Transcendence is passing over to being's *other*, otherwise than being. Not *to be otherwise*, but *otherwise than being*. And not to not-be; passing over is not here equivalent to dying. Being and not-being illuminate one another, and unfold a speculative dialectic which is a determination of being.
>
> —Emmanuel Levinas, *Otherwise Than Being Or Beyond Essence*

According to French philosopher Emmanuel Levinas, who combined the ideas of the German phenomenologists Edmund Husserl and Martin Heidegger, transcendence is not a modality of essence—not a question of being or not-being—but rather an ethical imperative; it is not a "safe" place of solipsistic inwardness, but a site of responsibility for others. In the transcendental beyond we are ordered toward the face of the other. In this beyond, in the "otherwise than being," subjectivity substitutes itself for another: it becomes the other in the same. It is inspired by the other—existing through the other and for the other without losing its original identity.

One artist who has been creating works that are intently transcendental is the German sculptor Wolfgang Laib, best known for his slabs of white marble covered with milk, his fields of yellow or orange pollen sifted onto floors, and his life-size rooms lined with beeswax panels. While all of his works are, in some sense, aimed at suspending reality, his intensely sensual wax chambers, in particular, are directed inward—they almost induce a loss of awareness of self or place. Even the recurring, succinct shapes of his sculptures—houses (p. 56), ships, pyramids, cones, and ziggurats—imply transgression, the going "Somewhere Else" (as in the title of one of Laib's sculptures).

Yet for Laib, art is an act of both transgression and participation—participating in nature and sharing that experience with others. The milk is not simply a white surface, but a living organic thing. Nor is the pollen simply a yellow rectangle: it is a field with no definite border, no strict, clean separation from the world outside it. Laib's works are

not merely visual experiences, but they serve as his contribution to social and spiritual change. According to Laib, art has to be "world-shaking" (*weltbewegend*). The spiritual reality of the work is embedded in its materiality—the two cannot be separated. Laib's "spiritual materialism" restores to the modern world picture what Husserl has called the "life-world," the naive, natural ground of conscious life that is a given—preceding any theoretical activity—just as, according to Levinas, the beyond is always already there. In that regard, transcendence is not art or religion at its conclusion but in its nascent state. Art has to be transcendental before it can be social.

The French art historian Georges Didi-Hubermann once described how, as we come face to face with sculpture (perceived as hollow, empty vessels), we experience a deep-seated fear of emptiness and death. He then cited two examples from art history that have dealt with this fear in opposite ways: Christian art takes comfort in faith by creating "myths" (such as depictions of the resurrection of Christ); and Minimalist art stands on tautology by claiming that there is nothing beyond what is manifest. Laib's sculptures (most of which are vessels) suggest a combination of both approaches. While he acknowledges the emptiness of his sculptures by filling them with rice or milk, these life-sustaining substances remain hidden or, in the case of the milkstones, become almost imperceptible. Thus, their content has to be taken on faith. The word "certitude," which appears in the titles of several of Laib's works, implies a leap of faith, a belief in something that needs no objective proof or cannot be subjected to it. In the work of artists such as Laib, James Turrell, Roni Horn, and James Lee Byars, this is certitude, the "believing in what we cannot know," is allied with a certain tautological knowledge, the "what you see is what you see" of Minimalism. The presence of this "tautological certitude" is evident throughout each artist's oeuvre. It is the promise made by transcendental art that substitutes subjectivity for the responsibility for the other.

SELECTED BIOGRAPHIES AND BIBLIOGRAPHIES

HELEN ALTMAN

Born in Tuscaloosa, Alabama, in 1958, Altman received her B.F.A. and M.A. from the University of Alabama in Tuscaloosa in 1981 and 1986 respectively. In 1989, she graduated with an M.F.A. degree from the University of North Texas in Denton. She has had solo exhibitions at Devin Borden Hiram Butler Gallery, Houston (1992, 1995, and 1998); Barry Whistler Gallery, Dallas (1992, 1995, and 1999); Museum of Southeast Texas, Beaumont (1997); John Michael Kohler Arts Center, Sheboygan, Wisconsin (1999); Dunn and Brown Contemporary, Dallas (2001); Moody Gallery, Houston (2001); and Women and Their Work, Austin, Texas (2001). Altman currently lives and works in Fort Worth, Texas.

Selected Readings

Auping, Michael. *Natural Deceits*. Fort Worth, Texas: The Modern Art Museum of Fort Worth, 2000.

Colpitt, Frances. *Just Ahead: Installations by Helen Altman*. Beaumont, Texas: Museum of Southeast Texas, 1997.

Davenport, Bill. "A Trailhead," *Helen Altman*. Austin, Texas: Women and Their Work, 2001.

Herbert, Lynn M., and Paola Morsiani. *Out of the Ordinary: New Art from Texas*. Houston: Contemporary Arts Museum, 2000.

Transformers: A Moving Experience. Auckland, New Zealand: Auckland Art Gallery, 1996.

JAMES LEE BYARS

Born in Detroit, Michigan, in 1932, Byars attended Wayne State University's Meril Palmer School of Psychology in Detroit. He has had solo exhibitions, many of which included performances, at The Museum of Modern Art, New York (1958); Metropolitan Museum of Art, New York (1970); Galerie Michael Werner, Cologne (1971–1972, 1981, 1984–87, 1989–91, 1994, and 1999–2000); Musée du Louvre, Paris (1975); Städtisches Museum Abteiberg, Mönchengladbach, Germany (1977); Westfälischer Kunstverein, Munster (1982); Musée d'Art Moderne de la Ville de Paris, Paris (1983); Institute of Contemporary Art, Boston (1984); Michael Werner Gallery, New York (1985, 1988, 1991, 1993, 1995–96, and 1998–2000); Castello di Rivoli, Museo d'Arte Contemporanea, Turin, Italy (1989); University Art Museum, University of California at Berkeley (1990); and IVAM Centre del Carme, Valencia, Spain (1994). Byars died in Cairo, Egypt, in 1997.

Selected Readings

Elliot, James, Achille Bonito Oliva, Carter Ratcliff, and Gianni Vattimo. *The Perfect Thought: Works by James Lee Byars*. Berkeley, California: University Art Museum, University of California at Berkeley, 1990.

Fuchs, Rudi, et al., eds. *The Great James Lee Byars: The Palace of Good Luck*. Turin, Italy: Castello di Rivoli, Museo d'Arte Contemporanea, 1989.

Haenlein, Carl, ed. *James Lee Byars: The Epitaph of Con.Art is which Questions have disappeared?* Hannover, Germany: Kestner Gesellschaft, 1999.

Harten, Jurgen, ed. *James Lee Byars – The Philosophical Palace*. Düsseldorf: Kunsthalle Düsseldorf, 1986.

James Lee Byars: The Perfect Moment. Valencia, Spain: IVAM Centre del Carme, 1995.

VIJA CELMINS

Born in 1939 in Riga, Latvia, Celmins enrolled at the John Herron Art Institute, Indianapolis, in 1958 and graduated with a B.F.A. in 1962. In the same year, she accepted a fellowship at the University of California in Los Angeles and graduated in 1965. She has had solo exhibitions at Whitney Museum of American Art, New York (1973); Newport Harbor Art Museum, Newport Beach, California (1980); McKee Gallery, New York (1983, 1988, 1992, 1996, and 2001); Institute of Contemporary Art, Philadelphia (1992); Fondation Cartier pour l'Art Contemporain, Paris (1995); and Institute of Contemporary Art, London (1996). Celmins curently lives and works in New York.

Selected Readings

Celmins, Vija, Jim Lewis, Nancy Princenthal, and Richard Shiff. "Vija Celmins." *Parkett Magazine*, no. 44 (1995), pp. 25–57.

Fine, Ruth E. *Gemini G.E.L.: Art and Collaboration*. New York: Abbeville, 1984.

Larsen, Susan C. *Vija Celmins: A Survey Exhibition*. Los Angeles: Fellows of Contemporary Art, 1979.

Tannenbaum, Judith, Douglas Blau, and Dave Hickey. *Vija Celmins*. Philadelphia: Institute of Contemporary Art, 1992.

Vija Celmins. Interview by Chuck Close. Los Angeles: A.R.T. Press, 1992.

LYNN DAVIS

Born in 1944 in Minneapolis, Minnesota, Davis studied at the University of Colorado, Boulder in1962–64, and the University of Minnesota in 1964–66; she obtained her B.F.A. from the San Francisco Art Institute in 1970. She has had solo exhibitions at Frankfurter Kunstverein, Frankfurt (1990); Centro Cultural Arte Contemporaneo, Mexico City (1991); Hirschl & Adler Modern, New York (1991); The Cleveland Museum of Art, Cleveland (1992); Lannan Foundation, Los Angeles (1992); Edwynn Houk Gallery, New York (1995–1996, 1998, and 2000–01); Center for Creative Photography, The University of Arizona, Tucson (1999); J. Paul Getty Museum, Los Angeles (1999); and John Berggruen Gallery, San Francisco (2001). Davis currently lives and works in Hudson, New York.

Selected Readings

Lynn Davis. New York: Edwynn Houk Gallery, 2000.

Lynn Davis: Ice. New York: Edwynn Houk Gallery, 2001.

Lynn Davis Photographien. Frankfurt: Frankfurter Kunstverein, 1990.

Smith, Patti, and Rudolph Wurlitzer. *Lynn Davis: Monument*. Santa Fe: Arena Editions, 1999.

Weiermair, Peter. *Lynn Davis: "Bodywork" 1978–85*. Zurich: Edition Stemmle, 1994.

KATHARINA FRITSCH

Born in 1956 in Essen, Germany, Fritsch attended Kunstakademie, Düsseldorf, in 1977 and completed advanced studies in 1981 under Fritz Schwegler. She has had solo exhibitions at Galerie Rüdiger Schöttle, Munich (1984); Galerie Johnen & Schöttle, Cologne (1985); Kaiser Wilhelm Museum, Krefeld, Germany (1987); Institute of Contemporary Art, London (1988); Kunsthalle, Basel (1988); Westfälischer

Kunstverein, Münster, Germany (1989); Dia Center for the Arts, New York (1993); Galerie Ghislaine Hussenot, Paris (1994); 46th Venice Biennale, German Pavilion, Venice (1995); Ludwigforum, Aachen, Germany (1996); Matthew Marks Gallery, New York (1996 and 2000); San Francisco Museum of Modern Art, San Francisco (1996); Museum für Gegenwartskunst, Basel, Switzerland (1997); Stadtische Galerie, Wolfsburg, Germany (1999); White Cube, London (1999); Kunstforum Bâloise, Basel (2000); and Museum of Contemporary Art, Chicago (2001). Fritsch currently lives and works in Düsseldorf, Germany.

Selected Readings

Ammann, Jean-Cristophe. *Katharina Fritsch*. Basel, Switzerland: Kunsthalle and London: ICA, 1988.

Heynen, Julien. *Katharina Fritsch 1979–1989*. Münster, Germany: Westfälischer Kunstverein and Frankfurt am Main: Portikus, 1989.

Cameron, Dan, Gary Garrels, and Julian Heynen. "*Setting Standards*." *Parkett*, no. 25 (September 1990), pp. 34–75.

Fritsch, Katharina. *Katharina Fritsch*. San Francisco: San Francisco Museum of Modern Art and Basel, Switzerland: Museum für Gegenwartskunst, 1996.

Zonia, Amanda. "Art That Goes Bump in the Night." *ARTnews* (November 1996), pp. 104–107.

ROBERT GOBER

Born in 1954 in Wallingford, Connecticut, Gober attended the Tyler School of Art in Rome in 1973–74, and obtained a B.A. from Middlebury College, Middlebury, Vermont, in 1976. He has had solo exhibitions at Paula Cooper Gallery, New York (1984–1985, 1987, 1989, and 1994); Daniel Weinberg Gallery, Los Angeles (1985–1986); The Art Institute of Chicago, Chicago (1988); Museum Boimans van Beuningen, Rotterdam, The Netherlands (1990); Galerie Nationale du Jeu de Paume, Paris (1991); Dia Center for the Arts, New York (1992); Serpentine Gallery, London (1993); Museum für Gegenwartskunst, Basel, Switzerland (1995); Museum of Contemporary Art, Los Angeles (1997); The Aldrich Museum of Contemporary Art, Ridgefield, Connecticut (1998); Walker Art Center, Minneapolis (1999); and 49th Venice Biennale, United States Pavilion, Venice (2001). Gober currently lives and works in New York.

Selected Readings

Benezra, Neal. *Robert Gober*. Exhibition pamphlet. Chicago: The Art Institute of Chicago, 1988.

Flood, Richard, Gary Garrels, and Ann Temkin. *Robert Gober: Sculpture + Drawing*. Minneapolis: Walker Art Center, 1999.

Foster, Hal, and Paul Schimmel. *Robert Gober*. Los Angeles: Museum of Contemporary Art, and Zurich, Berlin, and New York: Scalo, 1997.

Hickey, Dave, and Karen Marta. *Robert Gober*. New York: Dia Center for the Arts, 1992.

Rondeau, James, and Olga M. Viso. *Robert Gober—The United States Pavilion, 49th Venice Biennale.* Chicago: The Art Institute of Chicago and Washington, D.C.: Hirshhorn Museum and Sculpture Garden, Smithsonian Institution, 2001.

FELIX GONZALEZ-TORRES

Born in Güaimaro, Cuba, in 1957, Gonzalez-Torres received his B.F.A. from Pratt Institute, Brooklyn, New York, in 1983. In 1987, he received his M.F.A. from The International Center for Photography, New York University, New York. He has had solo exhibitions at The New Museum of Contemporary Art, New York (1988); Brooklyn Museum of Art, New York (1989); Andrea Rosen Gallery, New York, (1990–1993, 1995, and 1997); The Museum of Modern Art, New York (1992); Milwaukee Art Museum, Milwaukee, Wisconsin (1993); Museum in Progress, Vienna (1993); Museum of Contemporary Art, Los Angeles (1994); Solomon R. Guggenheim Museum, New York (1995); Musée d'Art Moderne de la Ville de Paris, Paris (1996); and Sprengel Museum, Hannover, Germany (1997). Gonzalez-Torres lived and worked in New York. He died in Miami, Florida, in 1996.

Selected Readings

Cahan, Susan, Jan Avgikos, Felix Gonzalez-Torres, and Tim Rollins. *Felix Gonzalez-Torres*. New York: A.R.T. Press, 1933.

Cruz, Amada, Russell Ferguson, Ann Goldstein, bell hooks, Joseph Kosuth, and Charles Merewether. *Felix Gonzalez-Torres: Traveling.* Los Angeles: Museum of Contemporary Art, 1994.

Deitcher, David, Dietmar Elger, Rainer Fuchs, Andrea Rosen, and Roland Wäspe. *Felix Gonzalez-Torres: Catalogue Raisonné and Text.* Hannover, Germany: Sprengel Museum, 1997.

Spector, Nancy. *Felix Gonzalez-Torres*. New York: Solomon R. Guggenheim Museum, 1995.

Spector, Nancy, Susan Tallman, and Simon Watney. *Parkett*, no. 39 (1994), pp. 24–69.

RODNEY GRAHAM

Born in 1949 in Vancouver, British Columbia, Graham attended the University of British Columbia, Vancouver, in 1968–71. He has had solo exhibitions at Galerie Johnen & Schöttle, Cologne (1986, 1988, 1990, and 1995); Christine Burgin Gallery, New York (1988 and 1990); Vancouver Art Gallery, Vancouver (1988); Stedelijk van Abbemuseum, Eindoven, The Netherlands (1989); Lisson Gallery, London (1990, 1993, 1997 and 2000); Galerie Rüdiger Schöttle, Munich (1991 and 1995); Angles Gallery, Santa Monica, California (1993 and 1997); Musée Départemental de Rochechouart, Haute Vienne, France (1995); 303 Gallery, New York (1995, 1997, and 2001); The Renaissance Society, Chicago (1996); 47th Venice Biennale, Canadian Pavilion, Venice (1997); Wexner Center for the Arts, Columbus, Ohio (1998); Donald Young Gallery, Chicago (1999); Museum of Contemporary Art, North Miami (1999); Dia Center for the Arts, New York (2000); Galerie Nelson, Paris (2001); and Hamburger Banhof-Museum für Gegenwart, Berlin (2001). Graham currently lives and works in Vancouver, British Columbia, Canada.

Selected Readings

Alberro, Alexander, Michael Glasmeier, Rodney Graham, and Shep Steiner. *Rodney Graham: Cinema, Music, Video*. Brussels: Yves Gevaert, in association with Kunsthalle Vienna, 1999.

Brayer, Marie-Ange, Boris Groys, Matthew Teitelbaum, and Jeff Wall. *Rodney Graham: Works from 1976 to 1994*. Toronto: Art Gallery of York University, 1994.

Debbaut, Jan, and Frank Lubbers. *Rodney Graham*. Eindhoven, The Netherlands: Stedelijk van Abbemuseum, 1989.

Gibson, William, Rodney Graham, Robert Linsley, and Shep Steiner. *Island Thought I, no.1*. Toronto: Art Gallery of York University, in association with Canada XLVII Biennale di Venezia, 1997.

Wall, Jeff. *Rodney Graham*. Vancouver: Vancouver Art Gallery, 1988.

ANN HAMILTON

Born in Lima, Ohio, in 1956, Hamilton received a B.F.A. in textile design from the University of Kansas, Lawrence, in 1979. She received an M.F.A. in sculpture from Yale University School of Art, New Haven, Connecticut, in 1985. She has had numerous solo exhibitions, including Museum of Contemporary Art, Los Angeles (1988); Capp Street Project, San Francisco (1989); Museum of Contemporary Art, San Diego (1990); 21st International São Paulo Bienal, São Paulo, Brazil (1991); MIT List Visual Arts Center, Cambridge, Massachusetts (1992); Dia Center for the Arts, New York (1993); The Museum of Modern Art, New York (1994); Tate Gallery Liverpool, Liverpool (1994); Sean Kelly Gallery, New York (1996); Stedelijk van Abbemuseum, Eindhoven, The Netherlands (1996); Wexner Center for the Arts, Columbus, Ohio (1996); Contemporary Arts Museum, Houston (1997); Musée d'Art Contemporain de Lyon, Lyon, France (1998); and 48th Venice Biennale, United States Pavilion, Venice (1999). Hamilton curently lives and works in Columbus, Ohio.

Selected Readings

Bruce, Chris, Rebecca Solnit and Buzz Spector. *Ann Hamilton*. Seattle: University of Washington, Henry Art Gallery, 1992.

Cooke, Lynne, Bruce Ferguson, Dave Hickey, and Marina Warner. *Ann Hamilton, tropos*. New York: Dia Center for the Arts, 1994.

Forsha, Lynda, and Susan Stewart. *ann hamilton*. San Diego: Museum of Contemporary Art, 1991.

Herbert, Lynn. *Ann Hamilton: kaph*. Houston: Contemporay Arts Museum, 1998.

Nesbit, Judith, and Neville Wakefield. *Ann Hamilton: mneme*. Liverpool: Tate Gallery, 1994.

HOWARD HODGKIN

Born in London, England, in 1932, Hodgkin studied at the Camberwell School of Art, London, and the Bath Academy of Art, Corsham, England. He has had numerous solo exhibitions, including Arthur Tooth and Sons, Ltd., London (1962 and 1967); Kasmin Gallery, London (1969 and 1971); André Emmerich Gallery, Zurich (1977–1978); M. Knoedler and Co., Inc., New York (1981–1982, 1984, 1986, 1990, and 1993–94); Phillips Collection, Washington, D.C. (1984); Venice Biennale, British Pavilion, Venice (1984); Kestner Gesellschaft, Hannover, Germany (1985); Whitechapel Art Gallery, London (1985); Yale Center for British Art, Yale University, New Haven, Connecticutt (1985); Musée des Beaux-Arts, Nantes, France (1990); Scottish National Gallery of Modern Art, Edinburgh (1990); University Art Museum, University of California at Berkeley (1991); Anthony d'Offay Gallery, London (1993–1994 and 1999–2000); The Modern Art

Museum of Fort Worth (1995); and Gagosian Gallery, New York (1998). Hodgkin currently lives and works in London and Wiltshire, England.

Selected Readings

Auping, Michael, John Elderfield, Marla Price, and Susan Sontag. *Howard Hodgkin Painting*. Fort Worth, Texas: The Modern Art Museum of Fort Worth, 1995.

Compton, Michael. *Howard Hodgkin: Indian Leaves*. London: Tate Gallery Publications, 1982.

Dickoff, Wilfried, and Timothy Hyman. *Howard Hodgkin*. Cologne: Michael Werner and New York: M. Knoedler and Co., 1990.

Lucie-Smith, Edward. *Howard Hodgkin*. London: Arthur Tooth and Sons, Ltd., 1962.

Morphet, Richard. *Howard Hodgkin, Forty-five Paintings: 1949–1975*. London: Arts Council of Great Britain, 1976.

JENNY HOLZER

Born in Gallipolis, Ohio in 1950, Holzer received a B.F.A. from Ohio University, Athens, Ohio in 1973 and an M.F.A. from the Rhode Island School of Design, Providence, Rhode Island, in 1977. She has had numerous solo exhibitions including Seattle Art Museum (1982); Barbara Gladstone Gallery, New York (1982–3, 1986, and 1994); Institute of Contemporary Art, University of Pennsylvania, Philadelphia (1983); Institute of Contemporary Art, London (1983); Kunsthalle, Basel, Switzerland (1984); Dallas Museum of Art, Dallas, Texas (1984 and 1993); Des Moines Art Center, Iowa (1986); The Brooklyn Museum, New York (1988); Dia Center for the Arts, New York (1989); The Solomon R. Guggenheim Museum, New York (1989); 44th Venice Biennale, United States Pavilion, Venice (1990); Walker Art Center, Minneapolis (1991); Albright-Knox Art Gallery, Buffalo, New York (1991); Louisiana Museum, Humelbaek, Denmark (1991); Art Tower Mito, Japan (1994); Williams College Museum of Art, Williamstown, Massachusetts (1995); Kunstmuseum des Kantons Thurgau, Kartause Ittingen, Warth, Switzerland (1996); Contemporary Arts Museum, Houston (1997); Cheim & Read, New York (2001); Musée d'Art Contemporain, Bordeaux (2001); and Neue Nationalgalerie, Berlin (2001).

Selected Readings

Auping, Michael. *Jenny Holzer: The Venice Installation*. Buffalo, New York: Albright-Knox Art Gallery, 1990.

Holzer, Jenny and Noemi Smolik. *Jenny Holzer: Writing*. Ostifildern-Ruit, Germany: Cantz Verlag, 1996.

Joselit, David, Joan Simon and Renata Saleci. *Jenny Holzer*. London: Phaidon Press Limited, 1998.

Kämmerling, Christian, Markus Landert, Beatrix Ruf, Noemi Smolik, and Yvonne Volkart. *Jenny Holzer. Lustmord*. Kartause Ittingen, Warth, Switzerland: Kunstmuseum des Kantons Thurgau, 1996.

Waldman, Diane. *Jenny Holzer*. New York: The Solomon R. Guggenheim Museum, 1989.

RONI HORN

Born in 1955 in New York City, Horn received a B.F.A. from the Rhode Island School of Design in Providence in 1975, and an M.F.A. from Yale University, New Haven, Connecticut, in 1978. She has had numerous solo exhibitions, including Kunstforum Lenbachhaus Museum, Munich (1983); Chinati Foundation, Marfa, Texas (1988); Detroit Institute of Arts, Detroit (1988); Museum of Contemporary Art, Los Angeles (1990); Städtisches Museum Abteiberg, Mönchengladbach, Germany (1991); Westfälischer Kunstverein, Münster, Germany (1991); Jablonka Galerie, Cologne (1992–1993, 1995, and 1997–1999); Matthew Marks Gallery, New York (1993, 1995–1997, and 1999); Baltimore Museum of Art, Baltimore (1994); Texas Gallery, Houston (1994); Kunsthalle, Basel, Switzerland (1995); Museum für Gegenwartskunst, Basel, Switzerland (1995 and 1998); St. Louis Museum of Art, St. Louis (1995); Wexner Center for the Arts, Columbus, Ohio (1996); Musée d'Art Contemporain, Bordeaux, France (1999); Musee d'Art Moderne de la Ville de Paris, Paris (1999); Castello di Rivoli, Turin, Italy (2000); Whitney Museum of American Art, New York (2000); and Dia Center for the Arts, New York (2001). Horn currently lives and works in New York.

Selected Readings

Bernadac, Marie Laure, Laurence Bosse, and Nancy Spector. *Events of Relation*. Paris: Musée d'Art Moderne de la Ville de Paris/capc Musée d'Art Contemporain, Bordeaux, 1999.

Cruz, Amada, Sherri Geldin, Felix Gonzalez-Torres, bell hooks, Roni Horn, and Sarah J. Rogers. *Earth Grows Thick*. Columbus, Ohio: Wexner Center for the Arts, 1996.

Fuchs, Rudi, and Hannelore Kersting. *Things That Happen Again*. Mönchengladbach, Germany: Städtischen Museum Abteiberg, Mönchengladbach, with Westfälischer Kunstverein, Münster, Germany, 1991.

Kertess, Klaus. *Roni Horn: Surface Matters*. Los Angeles: Museum of Contemporary Art, 1990.

Neri, Louise, Lynne Cooke, and Thierry de Duve. *Roni Horn*. London: Phaidon Press Limited, 2000.

ANISH KAPOOR

Born in Bombay, India, in 1954, Kapoor attended Hornsey College of Art and Chelsea School of Art, both in London. He has had numerous solo exhibitions including Lisson Gallery, London (1982–1983, 1985, 1988–1989, 1993, 1995, and 1998); Barbara Gladstone Gallery, New York (1984, 1986, 1989–1990, 1993, and 1998); Kunsthalle, Basel, Switzerland (1985); Centre Nationale d'Art Contemporain, Grenoble, France (1990); 44th Venice Biennale, British Pavilion, Venice (1990); Tate Gallery, London (1990); Centro de Arte Reina Sofia, Madrid (1991); Kunstverein, Hannover, Germany (1991); Museum of Contemporary Art, La Jolla, California (1992); Tel Aviv Museum of Art, Tel Aviv, Israel (1993); DePont Foundation, Tilburg, The Netherlands (1995); Centro Galega de Arte, Santiago de Compostela, Spain (1998); and Hayward Gallery, London (1998). Kapoor currently lives and works in London, England.

Selected Readings

Allthorpe-Guyton, Marjorie, and Thomas McEvilley. *Anish Kapoor. British Pavilion, XLIV Venice Bienale*. London: The British Council, 1990.

Bhahba, Homi, and Nehama Guralnik. *Anish Kapoor*. Tel Aviv: Tel Aviv Museum of Art, 1993.

Bhahba, Homi, and Pier Luigi Tazzi. *Anish Kapoor*. London: Hayward Gallery, 1998.

Celant, Germano. *Anish Kapoor*. Milan: Edizioni Charta, 1998.

Forsha, Linda, and Pier Luigi Tazzi. *Anish Kapoor*. La Jolla, California: Museum of Contemporary Art, 1992.

WOLFGANG LAIB

Born in Metzingen, Germany, in 1950, Laib received a medical degree in Tübingen, Germany in 1974. He has had numerous solo exhibitions including: 40th Venice Biennale, German Pavillion, Venice (1982); ARC, Musée d'Art Moderne de la Ville de Paris, Paris, (1986); Museum of Contemporary Art, Chicago (1989); Kunstmuseum, Bonn, Germany (1992); Musée National d'Art Moderne, Centre Georges Pompidou, Paris (1992); Museum of Contemporary Art, Los Angeles (1992); Sprengel Museum, Hannover, Germany (1995); Carré d'Art, Musee d'Art Contemporain, Nimes, France (1999); and Hirshhorn Museum and Sculpture Garden, Washington, D.C. (organized by American Federation of Arts, 2000). He currently lives and works in B. Biberach/Riss, Germany.

Selected Readings

Cladders, Johannes. *Wolfgang Laib*. Venice: Biennale di Venezia, German Pavilion, and Mönchengladbach, Germany: Städtisches Museum Abteiberg, 1982.

Ottmann, Klaus, and Margit Rowell. *Wolfgang Laib: A Retrospective*. With an interview with the artist by Harald Szeemann. New York: American Federation of Arts and Ostfildern-Ruit, Germany: Hatje Cantz Publishers, 2000.

Samsonow, Elisabeth von. *Wolfgang Laib*. With an interview with the artist by Rudolf Sagmeister. Bregenz, Austria: Kunsthaus Bregenz, 1999.

Schrenk, Klaus, Kerry Brougher, and Donald Kuspit. *Wolfgang Laib*. Bonn: Kunstmuseum, Los Angeles: Museum of Contemporary Art, and Ostfildern-Ruit, Germany: Edition Cantz, 1992.

Szeeman, Harald. *Wolfgang Laib*. With an interview with the artist by Suzanne Pagé. Paris: ARC, Musée d'Art Moderne de la Ville de Paris, 1986.

WALTER DE MARIA

Born in Albany, California, in 1933, de Maria attended the University of California at Berkeley in 1953–59, receiving his B.A. in history and M.A. in art. He has had numerous solo exhibitions, including Paula Cooper Gallery, New York (1965); Galerie Heiner Friedrich, Munich (1968); Kunstmuseum, Basel, Switzerland (1972); Hessisches Landesmuseum, Darmstadt, Germany, 1974; Centre Georges Pompidou, Paris (1981); Museum Boimans van Beuningen, Rotterdam, The Netherlands (1984); Arthur M. Sackler Museum, Cambridge, Massachusetts (1986); Staatsgalerie, Stuttgart, Germany (1987); Magasin 3, Stockholm Kunsthall, Stockholm (1988); Moderna Museet, Stockholm (1989); Gagosian Gallery, New York (1989 and 1992); and Kunsthaus, Zurich (1999). De Maria currently lives and works in New York.

Selected Readings

Beeren, Wim. *Walter de Maria.* Rotterdam, The Netherlands: Museum
Boimans van Beuningen, 1985.

Bott, Gerhard, and H. M. Schmidt. *Walter de Maria: The Large Earth
Room, 8 Sculptures, 44 Drawings.* Darmstadt, Germany: Hessisches
Landesmuseum, 1974.

Kellein, Thomas. *Walter de Maria: 5 Continent Sculpture.* Stuttgart,
Germany: Staib & Mayer, with Staatsgalerie, Stuttgart and DIA Art
Foundation, New York, 1988.

Meyer, Franz. *Walter de Maria Skulpturen.* Basel: Kunstmuseum Basel,
1972.

Silverthorne, Jeanne. *Walter de Maria.* Stockholm: Magazin 3 Stock-
holm Kunsthalle, 1988.

DONALD MOFFETT

Born in San Antonio, Texas in 1955, Moffett graduated from Trinity
University with a B.A. in art and biology. He has had solo shows at
Wessel O'Connor Gallery, New York (1989); Texas Gallery, Houston
(1991 and 2001); Jay Gorney Modern Art, New York (1996); Marc
Foxx, Los Angeles (2000); Stephen Friedman Gallery, London (2000);
and Museum of Contemporary Art, Chicago (2002). In 1988, Moffett
was one of the founding members of Gran Fury in 1988, an AIDS ac-
tivist collective, and he founded BUREAU, a transdisciplinary studio
the following year. Among his numerous group exhibitions is the
Whitney Biennial 1993, at the Whitney Museum of American Art,
New York. Moffett currently lives and works in New York.

Selected Readings

Ault, Julie. *Power Up: Reassembled speech, interlocking Sister Corita
and Donald Moffett.* (Hartford, Conn.: Wadsworth Atheneum, 1997).

Crimp, Douglas, and Adam Rolston. *AIDSDEMOGRAPHICS.* Seattle:
Bay Press, 1990.

Gonzales-Day, Ken. "Donald Moffett and Sister Corita Kent at Marc Foxx,
at UCLA Hammer Museum, at Luckman Fine Arts Gallery, California
State University, Los Angeles." *Art Issues* (Summer 2000), p. 53.

Wallis, Brian, ed. *Democracy: A Project/by Group Material.* Dia Center
for the Arts. Seattle: Bay Press, 1990.

Withers, Rachel. "Donald Moffett: Stephen Friedman Gallery." *Artfo-
rum* (January 2001), p. 150.

ERNESTO NETO

Born in Rio de Janeiro, Brazil, in 1964, Neto attended the Escola de
Artes Visuals Pargua Lage, Rio de Janeiro, and studied at the Museu
de Arte Moderna, Rio de Janeiro. His selected solo exhibitions include
Galeria de Arte do IBEU, Rio Centro Cultural São Paulo, São Paulo
(1991); Museu de Arte Moderna de São Paulo, São Paulo (1992);
Christopher Grimes Gallery, Santa Monica, California (1996–1997);
Galeria Camargo Vilaça, São Paulo (1997); Tanya Bonakdar Gallery,
New York (1998 and 2001); Contemporary Arts Museum, Houston
(1999); Institute for Contemporary Art, London (2000); James Van
Damme Gallery, Brussels (1999); SITE Santa Fe, Santa Fe (2000);
Wexner Center for the Arts, Columbus, Ohio (2000); Centro Galego
de Arte Contemporaneo, Santiago de Compostela, Spain (2001); 49th

Venice Biennale, Brazilian Pavilion, Venice (2001); Kiasma Museum
for Contemporary Art, Helsinki (2001); Kolnisher Kunstverein, Cologne
(2001); and University Art Museum, University of California at Berkeley
(2001). Neto currently lives and works in Rio de Janeiro, Brazil.

Selected Readings

Basualdo, Carlos. "Ernesto Neto." In *Cream: Contemporary Art in
Culture.* London: Phaidon Press Limited, 1998.

_____. "A Grammar of Exceptions." In *Ernesto Neto.* São Paulo:
Galeria Camargo Vilaça, 1998.

Celant, Germano. *Vik Muniz, Ernesto Neto.* São Paulo, Brazil: Brasil
Connects, 2001.

Herbert, Lynn M. *Ernesto Neto: Nhó Nhó Nave.* Houston: Contempo-
rary Arts Museum, 2000.

Herkenhoff, Paulo. "Cinco Desejos." In *Ernesto Neto.* São Paulo:
Galeria Camargo Vilaça, 1994.

Pedrosa, Adriano. *Ernesto Neto: naves, céus, sonhos.* São Paulo: Galeria
Camargo Vilaça, 1999.

RAYMOND PETTIBON

Born in Tuscon, Arizona, in 1957, Pettibon received his B.A. at the
University of California, Los Angeles, in 1977. He has had numerous
solo exhibitions, including Feature, New York (1989–91, and 1993);
University Art Museum, University of California at Berkeley, (1992);
Regen Projects, Los Angeles (1993, 1995, and 1998); Contemporary
Fine Arts, Berlin (1995, 1998, and 2001); Kunsthalle Bern, Bern,
Switzerland (1995); David Zwirner, New York (1995, 1997, and 2000);
Kunstverein für die Rheinlande und Westfalen, Düsseldorf (1997);
The Renaissance Society, Chicago (1998); The Drawing Center, New
York (1999); Museum of Contemporary Art, Los Angeles (1999);
Philadelphia Museum of Art, Philadelphia (1999); MAK, Vienna
(2001); and Whitechapel Art Gallery, London (2001). Pettibon
currently lives and works in Hermosa Beach, California.

Selected Readings

Cooper, Dennis. "Between the Lines: An Interview with Raymond
Pettibon." *L.A. Weekly,* 23, no. 26 (May 18–24, 2001), pp. 30–34.

Cooper, Dennis, Ulrich Loock, and Robert Storr. *Raymond Pettibon.*
London: Phaidon Press Limited, 2001.

Duncan, Michael. "Pettibon's Talking Pictures." *Art in America* (March
1999), pp. 106–109, 129.

Loock, Ulrich, ed. *Raymond Pettibon.* Bern and Paris: Kunsthalle Bern
and 14/16 Verneuil, 1995.

Temkin, Ann, and Hamza Walker, eds. *Raymond Pettibon. A Reader.*
Chicago: The Renaissance Society at the University of Chicago and
Philadelphia: Philadelphia Museum of Art, 1998.

QIU SHI-HUA

Born in Sichuan, China, in 1940, Qiu graduated from the Xian Art
Academy, Xian, in 1962. He has had numerous solo exhibitions in-
cluding Alliance Francaise, Hong Kong (1990); Hanart TZ Gallery,
Hong Kong (1991 and 1997); Kunsthalle, Basel, Switzerland (1999);
Galerie Urs Meile, Lucerne, Switzerland (2000); Rudolfinum, Prague

(2000); and Kunsthalle, New York (2001). He has been included in group exhibitions at Haus der Kulturen der Welt, Berlin (1996); São Paulo Biennale, São Paulo (1996); 48th Venice Biennale, Venice (1999); and Berlin Biennale 2, Berlin (2001). Qiu currently lives and works in San Francisco, California.

Selected Readings

Cohen, David. "Qiu Shi-hua." *artcritical.com*. May 2001.

Fricke, Christiane. "Natural Reality: Artist Positions between Nature and Culture." *Kunstforum International* (Sept.–Nov. 1999), pp. 408–10.

Kunz, Sabine. "Aufbruch in China [Emergence in China]." *ART: das Kunstmagazin* (May 2000), pp. 16–30, 32, and 34–35.

Reust, Hans Rufolf. "Qiu Shi Hua." *Artforum* (January 2000), p. 122.

Wechsler, Max. *Qiu Shi-hua*. Basel, Switzerland: Kunsthalle, 1999.

RACHEL RANTA

Born in Ely, Minnesota, in 1953, Ranta attended Maryville College, St. Louis, where she received a B.F.A., summa cum laude, in 1977. In 1988, she received an M.F.A. from the University of Houston, Houston. She has had solo exhibitions at W.A. Graham, Houston (1991–1992); Contemporary Arts Museum, Houston (1994); Sewall Art Gallery, Rice University, Houston (1994); and Texas Gallery, Houston (1997). She has been included in group exhibitions at The Galveston Art Center, Galveston, Texas (1991), San Antonio Museum of Art, San Antonio (1991); Blaffer Gallery, University of Houston, Houston (1993); West End Gallery, Houston (1993); and The Menil Collection, Houston (2001). Ranta currently lives and works in Houston, Texas.

Selected Readings

Chadwick, Susan. "Rachel Ranta: Picture Word." *Houston Post*, June 18, 1992, section D, p. 3.

Greene, Alison de Lima. *Texas: 150 Works from the Museum of Fine Arts, Houston*. Houston: The Museum of Fine Arts, Houston, 2000.

Johnson, Patricia C. "Discrete work reveals intriguing images." *Houston Chronicle*, May 26, 1994, section C, p. 12.

_____. "Still lifes foster sense of quiet: Eight Texas artists show breadth of genre." *Houston Chronicle*, January 27, 1991, *Zest* section, p. 17.

Ward, Elizabeth. *Darkness and Light: Twentieth Century Works from Texas Collections*. Blaffer Gallery, University of Houston, 1993.

CHARLES RAY

Born in Chicago, Illinois in 1953, Ray received a B.F.A. from the University of Iowa in Iowa City in 1975, and an M.F.A. from Mason Gross School of Art, Rutgers University, New Brunswick, New Jersey, in 1979. He has had numerous solo shows including 64 Market Street, Venice, California (1983); New Langton Arts, San Francisco (1985); Burnett Miller, Los Angeles (1987–1990); Feature, Chicago (1987–88); Feature, New York (1989–93); The Mattress Factory, Pittsburgh (1989); Claire Burrus, Paris (1990–91); Interim Art, London (1990); Newport Harbor Art Museum, Newport Beach, California (1990); University Art Museum, University of California at Berkeley (1990); Galerie Metropole, Vienna (1991 and 1993); Donald Young Gallery, Seattle (1992); Institute for Contemporary Art, London (1994);

Rooseum-Center for Contemporary Art, Mälmo, Sweden (1994); Regen Projects, Los Angeles (1997); and Museum of Contemporary Art, Los Angeles (1998). Ray currently lives and works in Los Angeles.

Selected Readings

Barnes, Lucinda, ed. *Charles Ray*. Newport Beach, Calif.: Newport Harbor Art Museum, 1990.

Bonami, Francesco. "Charles Ray." *Flash Art* (Italian edition), 24, no. 169 (1992), pp. 56–59.

Ferguson, Bruce W. *Charles Ray*. Mälmo, Sweden: Rooseum-Center for Contemporary Art, 1994.

Schimmel, Paul, and Lisa Phillips. *Charles Ray*. Los Angeles: Museum of Contemporary Art, 1998.

Schjeldahl, Peter. "Ray's Tack." *Parkett* (Switzerland), no. 37 (September 1993), pp. 18–28.

GERHARD RICHTER

Born in Dresden, Germany, in 1932, Richter attended Kunstakademie, Dresden in 1951–56 and 1961–63. He has had numerous solo exhibitions including Galerie Rudolf Zwirner, Cologne (1968, 1972, 1974, and 1987); Musée National d'Art Moderne, Centre Georges Pompidou, Paris (1977); Sperone Westwater Fischer Gallery, New York (1978, 1980, and 1983); Whitechapel Art Gallery, London (1979); Galleria Pieroni, Rome (1980, 1983, and 1987); Kunsthalle, Düsseldorf (1981 and 1986); Marian Goodman Gallery, New York (1985, 1987, 1990, 1993, 1996, and 2001); Sperone Westwater (1985, 1987, and 1990); Museum Moderner Kunst, Vienna (1986); Anthony d'Offay, London (1988, 1991–1992, 1995, and 1998); San Francisco Museum of Modern Art, San Francisco (1989); Tate Gallery, London (1991); ARC, Musée d'Art Moderne de la Ville de Paris, Paris (1993); Dia Center for the Arts, New York (1995); Carré d'Art, Musée d'Art Contemporain, Nîmes, France (1996); Sprengel Museum, Hannover, Germany (1998); and Kaiser Wilhelm Museum, Krefeld, Germany (2000). Richter currently lives and works in Düsseldorf, Germany.

Selected Readings

Ascherson, Neal, Stefan Germer, and Sean Rainbird. *Gerhard Richter*. London: Tate Gallery, 1991.

Buchloh, Benjamin H. D., Peter Gidal, and Birgit Pelzer. *Gerhard Richter*. 3 vols. Bonn: Kunstund Austellungshalle der Bundesrepublik Deutschland, 1993.

Criqui, Jean-Pierre, Peter Gidal, Dave Hickey, Gertrude Koch, and Birgit Pelzer. "Gerhard Richter Collaboration." *Parkett* 35 (1993).

Elger, Dietmar, and Oskar Bätschmann. *Gerhard Richter: Landcapes*. Hannover, Germany: Sprengel Museum, 1998.

Zweite, Armin. *Gerhard Richter: Atlas*. Munich: Städtische Galerie in Lenbachhaus and Cologne: Museum Ludwig, 1990.

BRIDGET RILEY

Born in London, England, in 1931, Riley attended Goldsmiths College and the Royal College of Art, both in London. She has had numerous solo exhibitions, including The Museum of Modern Art, New York (1966); 34th Venice Biennale, British Pavilion, Venice (1968); Hayward

Gallery, London (1970); Kunstverein, Hannover, Germany (1970); Albright-Knox Art Gallery, Buffalo, New York (1978); Fruitmarket Gallery, Edinburgh (1980); Tate Gallery, London (1994); Kunstverein für die Rheinlande und Westfalen, Düsseldorf (1999); Serpentine Gallery, London (1999); Dia Center for the Arts (2000); and PaceWildenstein, New York (2000). Riley lives and works in London and Cornwall, England, and in Vaucluse, France.

Selected Readings
Cooke, Lynne, and John Elderfield. *Bridget Riley: Reconnaissance.* New York: Dia Center for the Arts, 2001.

Hickey, Dave. "Not Knowing Bridget Riley." *Parkett,* no. 61 (May 2001), pp. 20–52.

Krajewsky, Michael, Robert Kudielka, Bridget Riley, and Raimund Stecker. *Bridget Riley: Selected Paintings 1961–1999.* With conversations with Ernest H. Gombrich and Michael Craig-Martin. Ostfildern-Ruit, Germany: Hatje Cantz, in association with Kunstverein für die Rheinlande und Westfalen, Düsseldorf, 1999.

Kudielka, Robert, ed. *Bridget Riley: Dialogues on Art.* Ed. Robert Kudielka. London: Zwemmer, 1995. Conversations with Michael Craig-Martin, Andrew Graham Dixon, Ernest H. Gombrich, Neil MacGregor, and Bryan Robertson. Introduction by Richard Shone.

The Eyes Mind: Bridget Riley. Collected Writings 1965–1999. Conversations with Alex Farquharson, Mel Gooding, Vanya Kewley, Robert Kudielka, and David Thompson. London: Thames and Hudson, Serpentine Gallery, and De Monfort University, 1999.

THOMAS RUFF

Born in Zell am Harmersbach, Germany, in 1958, Ruff attended Staatlichen Kunstakademie in Düsseldorf in 1977–85. He has had numerous solo exhibitions including Galerie Rüdiger Schöttle, Munich (1981, 1984, 1987, 1989, 1994–95, 1998, and 2000); Galerie Johnen & Schöttle, Cologne (1987, 1989, 1991, 1994–1995, 1997, and 1999); Mai 36 Galerie, Lucerne, Switzerland (1988 and 1990); Stedelijk Museum, Amsterdam (1989); 303 Gallery, New York (1989–1990, 1993, 1996, and 1998); Centre Nationale d'Art Contemporain, Grenoble, France (1990); Kunsthalle, Zurich (1990); Galerie Rüdiger Schöttle, Paris (1991); Mai 36 Galerie, Zurich (1993, 1995, 1997, 1999, and 2001); White Cube, London (1994); Rooseum-Center for Contemporary Art, Malmö, Sweden (1996); Centre Nationale de la Photographie, Paris (1997); Museum Haus Lange und Haus Esters, Krefeld, Germany (2000); Zwirner & Wirth, New York (2000 and 2001); Galerie Schöttle, Munich (2001); and Kunsthalle Baden-Baden (2001). Ruff currently lives and works in Düsseldorf, Germany.

Selected Readings
Brauchitsch, Boris V. *Thomas Ruff.* Frankfurt am Main, Germany: Museum für Moderne Kunst, 1992.

Pocock, Philip. "Interview with Thomas Ruff." *Journal of Contemporary Art,* 6, no. 1 (1993), pp. 78–86.

Wuffen, Thomas. "Reality So Real it's Unrecognizable. Interview with Thomas Ruff." *Flash Art,* no. 168 (January 1993), pp. 64–67.

Pohlen, Annelie. "Deep Surface." *Artforum* (April 1991), pp. 114–18.

Thomas Ruff: Portretten, Huizen, Steren. Amsterdam: Stedelijk Museum, 1989.

PAT STEIR

Born in Newark, New Jersey, in 1940, Steir studied graphic art at Pratt Institute, Brooklyn, in 1956–58. In 1958–60, she studied at Boston University, then returned to Pratt Institute and received her BFA from that institution in 1961. She has had solo exhibitions at The Corcoran Gallery of Art (1973); Max Protech Gallery, Washington, D.C. (1973); Galerie Farideh Cadot, Paris (1976, 1978–82); Max Protech Gallery, New York (1980–81); The Brooklyn Museum of Art, Brooklyn (1984 and 1997); Cincinnati Art Museum, Cincinnati (1985); Dallas Museum of Art, Dallas (1986); M. Knoedler & Co., Inc., New York (1987–88); Rijkmuseum Vincent van Gogh, Amsterdam (1987), The Baltimore Museum of Art, Baltimore (1988); Kunstmuseum, Bern, Switzerland (1988); Musee d'Art et d'Historie, Geneva (1988); Robert Miller Gallery, New York (1990, 1992, 1995, and 1997); Musée d'Art Contemporain, Lyon, France (1990); National Gallery of Art, Washington, D.C. (1990); Galerie Franck + Schulte, Berlin (1991, 1993, and 1995–96); Centre National d'Art Contemporain de Grenoble, France (1992); The Irish Museum of Modern Art, Dublin (1994 and 1996); Rhona Hoffman Gallery, Chicago (1998 and 2000); P.S. 1 Contemporary Art Center, Long Island City, New York (1998); Whitney Museum of American Art, New York (1998); Albright-Knox Art Gallery, Buffalo, New York (1999); Marlborough Gallery, New York (1999); and Madison Art Center, Madison, Wisconsin (2001). Steir currently lives and works in New York and Amsterdam.

Selected Readings
Cotter, Holland. *Pat Steir: Waterfalls.* New York: Robert Miller Gallery, 1990.

Mayo, Marti and Pat Steir. *Arbitrary Order: Paintings by Pat Steir.* Houston: Contemporary Arts Museum, 1983.

McEvilley, Thomas. *Pat Steir.* New York: Harry N. Abrams, Inc., Publishers, 1995.

Ratcliff, Carter, and Pat Steir. *Pat Steir Paintings.* New York: Harry N. Abrams, Inc., Publishers, 1986.

Steir, Pat, John Yau, and Barbara Weidle. *Dazzling Water, Dazzling Light.* Seattle: University of Washington Press, 2000.

NESTOR TOPCHY

Born in 1963 in Somerville, New Jersey, Topchy received a B.F.A. from the Maryland Institute, College of Art, Baltimore, in 1985. In 1987, he received an M.F.A. from the University of Houston, Houston. His work has been included in exhibitions and performances at Contemporary Arts Museum, Houston (1994); DiverseWorks, Houston (1994); Museum of Fine Arts, Houston (1995); Hiram Butler Gallery, Houston (1995); The Jones Center for Contemporary Art, Texas Fine Arts Association, Austin, Texas (1999); The Menil Collection, Houston (1999); Arlington Museum of Art, Arlington, Texas (2001); and Project Row Houses, Houston (2001). He is the founder and creative director of TemplO art center in Houston. Topchy currently lives and works in Houston.

Selected Readings
Colpitt, Frances. "Space City Takes Off." *Art in America* (October 2000), pp. 67–73 and 75.

JAMES TURRELL

Born in Los Angeles, California, in 1943, Turrell received a B.A. in psychology from Pomona College, Claremont, California, in 1965, and an M.A. art from Claremont Graduate School, Claremont, California, in 1973. He has had numerous solo exhibitions including Stedelijk Museum, Amsterdam (1976); Whitney Museum of American Art, New York (1980); Leo Castelli, New York (1981); Mattress Factory, Pittsburg (1983); Musée d'Art Moderne de la Ville de Paris, Paris (1983); Marian Goodman Gallery, New York (1985–1986); Museum of Contemporary Art, Los Angeles (1985); The Museum of Modern Art, New York (1990); Newport Harbor Art Museum, Newport Beach, California (1990); Anthony d'Offay Gallery, London (1991 and 1993); Kunstmuseum, Bern, Switzerland (1991); Fundación La Caixa, Madrid (1992); Henry Art Gallery, Seattle (1992); Kunstammlung für Nordrhein und Westfalen, Düsseldorf (1992); Musée d'Art Contemporain, Lyon, France (1992); Hayward Gallery, London, (1993); Institute of Contemporary Art, Philadelphia (1993); Barbara Gladstone Gallery, New York (1994 and 1998); Hiram Butler Gallery, Houston (1995); Art Tower Mito, Ibaraki, Japan (1995); Castello di Rivoli, Turin, Italy (1996); Michael Hue-Williams Fine Art, London (1996 and 1998); Museum of Modern Art, Saitama, Japan, (1997); Contemporary Arts Museum, Houston (1998); and Osterreisches Museum für Angewandte Kunst (MAK), Vienna (1998). Turrell currently lives and works in Flagstaff, Arizona.

Selected Readings

Birnbaum, Daniel, Georges Didi-Huberman, Michael Rotondi, and Paul Virilio. *James Turrell: the other horizon*. Vienna: Osterreisches Museum für Angewandte Kunst (MAK), 1999.
Brown, Julia, ed. *Occluded Front: James Turrell*. Los Angeles: Museum of Contemporary Art, Los Angeles, 1985.
Herbert, Lynn, John H. Lienhard, J. Pittman McGehee, and Terence Riley. *James Turrell: Spirit and Light*. Houston: Contemporary Arts Museum, 1998.
James Turrell: Hemels Gewelf in Kijkduin (Celestial Vault in the Dunes). The Hague, The Netherlands: stroom, The Hague Centre for Visual Arts, 1996.
Osaka, Erica, Atsushi Sugita, and Richard L. Walker. *James Turrell*. Ibaraki, Japan: Contemporary Art Center, Art Tower Mito, 1995.

BILL VIOLA

Born in New York City, in 1951, Viola received a B.F.A. from Experimental Studios, College of Visual and Performing Arts, Syracuse University, Syracuse, New York in 1973. He has had numerous solo exhibitions including The Museum of Modern Art, New York (1979 and 1987); Musée d'Art Moderne de la Ville de Paris, Paris (1983); Moderna Museet, Stockholm (1985); Fondation Cartier pour l'Art Contemporain, Jouy-en-Josas, France (1990); Anthony d'Offay Gallery, London (1992 and 2001); Donald Young Gallery, Seattle (1992); Musée des Beaux-Artes, Nantes, France (1992); Stadtische Kunsthalle, Düsseldorf (1992); Musée d'Art Contemporain de Montréal, Montréal (1993); 46th Venice Biennale, United States Pavilion, Venice (1995); Guggenheim Museum (SoHo), New York (1997); Whitney Museum of American Art, New York (1997); and James Cohan Gallery, New York (2000). Viola currently lives and works in Long Beach, California.

Selected Readings

Adriani, Götz, Reto Krüger, Ralph Melcher, Bill Viola, and Dörte Zbikowski. *Stations: Bill Viola*. Karlsruhe, Germany: Museum für Neue Kunst/ZKM, 2000.
Bill Viola: Statements by the Artist. With introduction by Julia Brown. Los Angeles: Museum of Contemporary Art, 1985.
Duguet, Anne-Marie, John G. Hanhardt, Kathy Huffman, Suzanne Page, and Bill Viola. *Bill Viola*. Paris: Musée d'Art Moderne de la Ville de Paris, 1983.
Hyde, Lewis, Kira Perov, David A. Ross, and Bill Viola. *Bill Viola: A 25 Year Survey*. New York: Whitney Museum of American Art, 1997.
Violette, Robert, ed., with Bill Viola. *Reasons for Knocking at an Empty House: Writings 1973–1994*. Cambridge, Mass.: The MIT Press and London: Thames and Hudson, 1995.

ROBERT WILSON

Born in Waco, Texas in 1941, Wilson studied in Paris under the American painter George McNeil in 1962, before completing a degree in interior design from the Pratt Institute in Brooklyn in 1965. He has had numerous solo exhibitions, including Marian Goodman Gallery, New York (1977, 1979, and 1982); Paula Cooper Gallery, New York (1979, 1984, 1987, 1991–1992, 1994, 1996 and 2000); Museum Boimans van Beuningen, Rotterdam, The Netherlands (1983 and 1993); Walker Art Center, Minneapolis (1984); Grey Art Gallery, New York University, New York (1986); Laguna Gloria Art Museum, Austin, Texas (1986); Stedelijk Museum, Amsterdam (1989); Centre Georges Pompidou, Paris (1991); Museum of Fine Arts, Boston (1991); Galerie Franck + Schulte, Berlin (1992); Galerie Thaddeus Ropac, Paris (1992–93 and 1995–96); Hiram Butler Gallery, Houston (1992, 1995, and 1999); Instituto Valenciano de Arte Moderno, Valencia, Spain (1992); Galeries Lafayette, Paris (1996); Musée des Beaux Arts de la Ville de Paris, Paris (1999); and Museum of Contemporary Art, Chicago (1999). Also an acclaimed theatrical designer and director, Wilson has staged productions at theaters around the world, including the Brooklyn Academy of Music, Teatro alla Scala, Opéra Bastille, Metropolitan Opera, Oberammergau, and Kennedy Center. He is the director of the Watermill Center, a multidisciplinary arts laboratory in Long Island. Wilson currently lives and works in New York.

Selected Readings

Brecht, Stefan. *The theatre of visions: Robert Wilson*. Frankfurt am Main: Suhrkamp, 1979.
Fairbrother, Trevor. *Robert Wilson's Vision : An exhibition of works by Robert Wilson with a sound environment by Hans Peter Kuhn*. Boston: Museum of Fine Arts, 1991.
Holmberg, Arthur. *The Theatre of Robert Wilson*. Cambridge, England: Cambridge University Press, 1997.
Rockwell, John, Laurence Shyer, Robert Stearns, and Calvin Tomkins. *Robert Wilson: The Theater of Images*. New York: Harper and Row, 1984.
Shyer, Laurence. *Robert Wilson and his collaborators*. New York: Theatre Communications Group, 1989.

Staff

Tim Barkley, *Registrar*

Tamika Beatty, *Gift Acknowledgment Coordinator*

Cheryl Blissitte, *Administrative Assistant, Director's Office*

Robert Bowden, *Finance Officer*

Diane Bulanowski, *Security Supervisor*

Valerie Cassel, *Associate Curator*

Claire Chauvin, *Web Site Designer*

Kristina Cramer-Bergeron, *Development Associate*

Ebony Edwards-McFarland, *Public Relations and Marketing Associate*

Kenya F. Evans, *Assistant Security Supervisor/Assistant Preparator*

Natividad Flores, *Housekeeping*

Peter Hannon, *Preparator*

Lynn M. Herbert, *Senior Curator*

Marti Mayo, *Director*

Paola Morsiani, *Associate Curator*

Paula Newton, *Director of Education and Public Programs*

Grace Pierce, *Assistant Director of Development*

Peter Precourt, *Education and Public Programs Assistant*

Sue Pruden, *Museum Shop Manager*

Michael Reed, *Assistant Director*

Karen Skaer Soh, *Director of Development*

Lana Sullivan, *Receptionist/Staff Secretary*

Kim Webb, *Development Assistant*

Amber Winsor, *Development Associate*

Authors

Lynn M. Herbert is Senior Curator at the Contemporary
Arts Museum, Houston.

Klaus Ottmann is an independent curator and writer based
in New York. He is currently organizing a retrospective
exhibition of James Lee Byars for the American Federation
of Arts.

Peter Schjeldahl is an art critic for *The New Yorker*.

Courtesy Tanya Bonakdar Gallery, New York; p. 63
Courtesy Cheim & Read, New York; p. 79
Geoffrey Clements; courtesy Robert Gober; p. 41
Courtesy James Cohan Gallery, New York; p. 85
Prudence Cuming, London; courtesy PaceWildenstein, New York;
 © 2001 Bridget Riley All Rights Reserved; p. 75
©Lynn Davis; courtesy Edwynn Houk Gallery, New York; p. 37
D. James Dee; courtesy Sean Kelly Gallery/Projects, New York; p. 47
Courtesy Dunn and Brown Contemporary, Dallas; pp. 30–31
Courtesy Fisher Landau Center, Long Island City, New York; p. 45
Rick Gardner, Houston; pp. 51, 81, and 87
Hester + Hardaway, Fayetteville, Texas; p. 83
Andy Keate Photography; courtesy Stephen Friedman Gallery,
 London; p. 61
Courtesy Kunsthalle Basel; pp. 66–67
Courtesy Matthew Marks Gallery, New York; p. 39
Courtesy McKee Gallery, New York; p. 35
Robert McKeever; courtesy Gagosian Gallery, New York; p. 59
Courtesy Modern Art Museum of Fort Worth; p. 49
Courtesy The Museum of Contemporary Art, Los Angeles; p. 71
Courtesy Anthony d'Offay Gallery, London; p. 73
Orcutt & Van der Putten, New York; courtesy David Zwirner
 Gallery, New York; p. 65
© 1990 Douglas M. Parker, LA, CA, USA; Courtesy Matthew Marks
 Gallery, New York; p. 53
Philipp Scholz Rittermann; © Anish Kapoor, 1989; p. 55
Courtesy Andrea Rosen Gallery, New York, in representation of the
 Estate of Felix Gonzalez-Torres; p. 43
Courtesy Sperone Westwater, New York; p. 57
Courtesy Texas Gallery, Houston; pp. 68–69
Courtesy Michael Werner, Inc., New York; p. 33
Courtesy Zwirner & Wirth, New York; p. 77

Catalogue

Publication coordinator: Lynn M. Herbert
Editors: Polly Koch and Michelle Nichols
Research: Billy Baron, Peggy Ghozali, and Karmin Guzder
Design: Don Quaintance, Public Address Design, Houston
Design and Production Assistant: Elizabeth Frizzell
Typography: Composed in Futura (display) and Minion (text)
Color separations/printing: Champagne Fine Printing, Houston